Lynn Chadwick
Dennis Farr

Published by order of the Tate Trustees on
the occasion of the exhibition at Tate Britain
15 September 2003 – 21 March 2004

First published in 2003 by Tate Publishing,
a division of Tate Enterprises Ltd,
Millbank, London SW1P 4RG
www.tate.org.uk

British Library Cataloguing in Publication Data
A catalogue record for this book is available
from the British Library

ISBN 1 85437 467 2 (pbk)

Distributed in the United States and Canada
by Harry N. Abrams, Inc., New York

Library of Congress Cataloging
in Publication Data
Library of Congress Control Number:
2003108541

Designed by Rose Design
Printed in Italy by Conti Tipocolor

Front cover:
Lynn Chadwick, *Maquette for The Stranger*
1954 (fig.13, detail)
Back cover and frontispiece:
Photograph of Lynn Chadwick, 1960s

Note: the line drawings that appear in the text
are taken from Chadwick's Workbooks. Almost
without exception these are record drawings
and were not preliminary ideas for sculpture.
There is a section of colour illustrations,
pp. 105–12, numbered separately as plates.

Contents

6 Foreword
7 Acknowledgements
8 *Lynn Chadwick*
113 Biography
117 Notes
121 Select Bibliography
122 List of Exhibited Works
125 List of Additional Illustrations
126 Lenders and Credits
127 Index

Foreword

Lynn Chadwick came late to sculpture but was soon launched on the international stage as one of a new generation of British sculptors shown at the Venice Biennale in 1952. When he beat Alberto Giacometti to win the International Prize for Sculpture in Venice in 1956 it was the sensation of the show. He went on to secure an international reputation with works in many of the great public collections of Europe, North and South America, and Japan. Yet he has never been the subject of a Tate exhibition. It was, therefore, with great pleasure that we accepted the proposal from Dennis Farr, a long-time advocate of the artist's work, that the time was ripe for Tate Britain to take a retrospective look at Chadwick's fifty years of achievement.

Dennis Farr has drawn on his great experience as a curator and deep knowledge of Chadwick's work to select the exhibition and write this accompanying book. We are hugely indebted to Lynn Chadwick's family, most especially Eva Chadwick and his daughter Sarah Marchant, for lending the majority of the works on display and for assisting in every aspect of the preparations. We are also grateful to Bristol City Art Gallery, the Arts Council Collection and Sculpture at Goodwood for lending important works from their collections. At Tate Britain, curator Chris Stephens oversaw the planning and implementation of the whole project, supported by Laura Davies, conservator, and Ken Graham, senior technician, and his team. We are grateful too to Nicola Bion and Fran Matheson of Tate Publishing, and Simon Elliott of Rose Design, for producing such a beautiful book.

It was with great sadness, during the final stages of planning of the exhibition earlier this year, that we learnt of Lynn Chadwick's death. We had very much looked forward to him seeing his work in the Duveen Galleries, but I am pleased to know that, despite ill-health, he was aware and appreciative of our plans. I trust that the exhibition and this book go some way towards a fitting memorial to his extraordinary contribution to British sculpture.

Stephen Deuchar
Director
Tate Britain

Acknowledgements

I am very grateful to the Director of Tate Britain, Stephen Deuchar, for his early support of the idea of a Lynn Chadwick display and to Roger Thorp, Director of Tate Publishing, for his decision to publish a monograph to coincide with the opening of the exhibition. I also gladly acknowledge the support I have received from Chris Stephens, Senior Curator, Exhibitions and Displays Department, Tate Britain, who has thought out the display with me and coordinated all the technical work connected with it. He also read the text of this essay and made some helpful comments, but I must take full responsibility for the interpretation of Lynn Chadwick's work.

Lynn and Eva Chadwick, and Lynn's daughter Sarah Marchant, have enthusiastically assisted us in every practical way.

We thank them most warmly, and also those lenders to the exhibition, who have provided some key early sculptures: Bristol City Art Gallery and the Hayward Gallery, London. By far the greatest debt is owed to Lynn and Eva Chadwick who have lent the bulk of the works displayed.

I would like to thank Simon Elliott and Catherine McLeman of Rose Design, London; my editor Nicola Bion of Tate Publishing, and lastly my wife, Diana, for her generous logistical support and encouragement.

These acknowledgements were written before Lynn's death on 25 April 2003, so a celebration of a remarkable career has now also become, sadly, a memorial exhibition. It is some consolation to us that Lynn had the pleasure of knowing that the plans for his exhibition at Tate Britain had reached an advanced stage before he died.

Dennis Farr

Lynn Chadwick

Lynn Chadwick came to sculpture by an unconventional route: he did not attend art school, but like his near-contemporary, Reg Butler (born 13 April 1913), began his professional career in an architect's office as a draughtsman.[1] Although Chadwick never qualified as an architect, a sense of mass, order and design is inherent in architecture and, by extension, in sculpture. These are qualities found in Chadwick's sculpture, which began with his mobiles as a semi-abstract form of expression, before evolving into more obviously naturalistic figurative sculptures. Throughout his work, even at its most abstract and geometric, there is usually an allusion to natural forms that underpins and gives vitality to it, whether he is working on a small scale, as in his maquettes, or in his monumental, hieratic figure groups that he began to develop in the 1960s. There is movement, too, often implied rather than overt, although even here this generalisation needs immediate qualification, when we look at his winged and caped figures, or the female figures with windblown hair and swirling dresses.

There is a sense in which, reviewing the whole of Chadwick's work over the past fifty years or so, the wheel has come full circle: from the early suspended mobiles and stabiles, where movement is explicit but random, to the late groups of women ascending and descending a spiral staircase, where he has been intrigued by the subtle interplay of forms in controlled movement. That Chadwick was well aware of the general direction that his work was following may be gauged from a perceptive comment he made as early as 1955:

> If I look back on my work over a period of years, I can see a development from mobiles and constructions, on to beaten shapes with limbs and connections, to the solid forms on which I'm now working. It seems there has been a deliberate continuity, as if the mobiles had been a research into space and volume (separate parts free in space), and the constructions had been a way of joining the parts together, fixing them in space to make forms, and that these constructions have become armatures for the solid shapes – the iron frames of the construction still delineate the mass and act as lines of tension.[2]

He continued by explaining that in his use of the technique of welding in iron (and, from 1955, casting the welded sculptures in bronze) he

stresses the character imposed by the medium: 'I can straighten or bend or taper, but there are limitations, and I visualize in terms of the possibilities and limitations. I believe that it is necessary for the artist to have feeling for the method in which he works, whatever his medium.'[3] He speaks of an 'organic reality' of his forms, 'as if they were the logical expression of the materials which I use. I do not expect much vitality in my work unless this is so.'[4]

> Apart from these practical considerations I do not analyse my work intellectually. When I start to work I wait till I feel what I want to do; and I know how I am working by the presence or lack of a rhythmic impulse. I think that to attempt to analyse the ability to draw ideas from their subconscious source would almost certainly interfere with that ability.[5]

This emphasis on the intuitive nature of artistic creation recurred frequently in any discussion of his work, and in 1987 when interviewing him, I was struck by both his pragmatic and intuitive approach to sculpture; there is a consistency and homogeneity to his work that impresses us as the expression of a unique artistic personality. Themes are explored and reworked with subtle variations, a process familiar enough in any major artist's work, and Chadwick is no exception. What surprises us, when confronted by a representative selection of his work over a life's span, is just how varied is the formal language he uses and yet how distinctively personal it remains, how unmistakably the creation of one man's genius.

Overleaf
Photograph of Lynn Chadwick
c. 1952

Early Career

Before embarking on a detailed discussion of his work, we need to know about Chadwick's early life and upbringing, and of the formative influences on his career.[6] Born at Ivy Cottage, Station Road, Barnes, on 24 November 1914, the elder child and only son of Verner Russell Chadwick and Margery Brown Lynn, he grew up in comfortable middle-class circumstances. After attending a local preparatory school, he received his formal education at Merchant Taylors' School, then located at Charterhouse Square in the City of London, and to which he commuted daily. He was taught a traditional public school classical syllabus, which included Latin, Greek, Mathematics and French; he enjoyed sport, and was taught oil and watercolour painting by the art master K.F.P. Brown ARCA. His father was a successful engineer, originally from Lancashire, and director of the Turbine Furnace Company. His mother's father was a cabinet-maker and antiquarian, and both parents, while encouraging any artistic leanings Chadwick may have had, wisely advised him to abandon his somewhat romantic notion of pursuing a precarious full-time career as a sculptor in favour of a practical profession by which he could earn a living in the depressed economic climate of the early 1930s. Years later, Chadwick's father was to admit to being at first disappointed that his son did not become an architect; however, his attitude completely changed when Chadwick triumphed at the Venice Biennale, although Lynn knew that his father could never quite understand his work.

Chadwick's first job, in autumn 1933, was with Donald Hamilton, himself an old Merchant Taylor who practised in London, and for whom Chadwick drew sections for shop-fronts for Lilley & Skinner. He then worked briefly with a refugee German architect, Eugen C. Kaufmann, who had abandoned a distinguished career as Städtischer Baurat in Frankfurt-am-Main. After an interlude working in the USSR (1931–3), he came to England in 1933. He, too, specialised in shop-fronts, and his work and style were later described by Chadwick as 'stuffy modern'.[7] In 1937 Chadwick joined Rodney Thomas's London practice as a draughtsman, for whom he worked on gas showrooms for the Ascot Water Heaters Company. Thomas was later to be an important influence on Chadwick's embryonic career as a sculptor. Chadwick had tried to study to become

a fully qualified architect and attended evening classes at the Regent Street Polytechnic, but he found the theoretical side of an architect's training beyond him at that time. Later he also realised that an architect, to be at all successful, had to combine business acumen with artistic flair, and he very much doubted his capacities as a business manager.[8]

Chadwick was sent to France in 1932 to improve his French, and stayed at Vouvray, near Tours, and some charming watercolours he painted there still survive which show that he had mastered the medium. He also went to Paris and visited Père Lachaise cemetery to see Jacob Epstein's tomb for Oscar Wilde, which he much admired but felt the location did the sculpture a disservice. Years before, his parents had taken him to see Epstein's *Rima* in Kensington Gardens soon after it was unveiled in 1925, doubtless because it had become an object of public controversy, and possibly to show the young Chadwick one of the 'horrors' of modern art.[9] He was also taken to see the Turners and Constables in the Tate Gallery, where he remembered seeing, too, some of Samuel Courtauld's Impressionist and Post-Impressionist paintings. They took him to the G.F. Watts Gallery at Compton, near Godalming. He had also seen Watts' sculpture, *Physical Energy*, in Hyde Park, and there could hardly be a greater contrast between Watts' work, then still revered, and that of Epstein, which had attracted hostility from diehard traditionalists ever since his nude sculptures for the British Medical Association's headquarters in the Strand (now the Zimbabwe High Commission) were unveiled in 1908.

Chadwick's knowledge of modern painting and sculpture was inevitably patchy. The Merchant Taylors' art master seems never to have discussed the wider realms of art with his pupils, but was more concerned with technique. Apart from childhood visits to Ostend with his parents, a visit to France and a cheap package-tour skiing holiday in Germany in about 1936, Chadwick had not then been able to travel extensively. He remembers the excitement generated by the MARS Group exhibition *New Architecture* held in London at the New Burlington Galleries in January 1938, at which a more forward-looking vision of architecture was presented by a group of young British architects and some distinguished refugee German architects to a wider public. Le Corbusier was a hero to the younger generation, but according to John Summerson the distinguished man's response on seeing the exhibition was a muttered *'pénible'* ('painful')![10]

Chadwick's holiday in Germany had brought him into contact with his German contemporaries, and he remembers the earnest political discussions that took place among the Hitler Jugend zealots, discussions that to him, as an apolitical animal, were distinctly unattractive. Nevertheless, he was aware of the upheavals taking place in Central Europe, but when war broke out in September 1939, although not a convinced pacifist, he did not feel able immediately to join up. He worked as a farm labourer in Herefordshire from 1940–41; this was a reserved occupation and he could not be called up for military service in the usual way. However, by the autumn of 1941 he felt morally obliged to join up, and was allowed to volunteer for flying duties and joined the Fleet Air Arm of the Royal Navy. After training in the USA and Canada, he qualified as a pilot and was commissioned in to the RNVR. Posted to aircraft carriers, his duties included escorting convoys in the North Atlantic and protecting them from U-boat attacks. He was demobilised as a senior pilot in spring 1944, then returned to Rodney Thomas's office, and rented a house in Cheyne Row, Chelsea. He had met and married Charlotte Ann Secord in Toronto in 1942, and had a son, Simon, to support.

Mobiles and the First Sculptures

There was little scope for grand architectural projects in Britain during the immediate post-war years, but there was an acute need for new housing, and the rebuilding of bomb-shattered towns and cities, and of factories and the industrial infrastructure, took priority. Strict planning controls, combined with shortages of raw materials and money, meant that architects could only freely exercise their creative skills for the most part in temporary exhibition work. By April 1945, Chadwick had begun to carve a niche for himself as a designer, and described himself as such on his passport; only later did he give his profession as sculptor.[11] By winning a £50 prize in a textile design competition in March 1946, he boosted his career as a designer, and the sponsors, Ascher (London) Ltd, offered him a contract to produce ten designs a year at a price of £15 each.[12] Chadwick's designs, some of which survive in a book dated June to September 1946 are based on plant forms or architectural motifs; most are derived from organic shapes, not unlike the ectoplasmic forms in Jean Arp's sculpture and paintings, or the interflowing forms of, say, Bertholdt Lubetkin's Penguin Pool for the London Zoo of 1934. Chadwick acknowledged that those architectural idioms, which were part of the design currency of the day, had also influenced his own work.

If Le Corbusier and Walter Gropius were the revered icons of the more radical younger generation of British architects, Epstein, Henry Moore and Barbara Hepworth were the sculptors who exerted the greatest influence on the rising generation of British sculptors, not so much for founding a school of followers but rather by their example. In sculpture, Auguste Rodin was the great liberating force at the beginning of the twentieth century, just as in painting Picasso and Matisse were the pioneers of a radical new approach to art (and one may note that both men also produced sculpture of an untraditional kind). Whereas previously sculptors had been exclusively concerned with the problems of producing solid, three-dimensional objects, the advent of Cubism brought a new conception of space in which the human figure was either split open or pierced, or else completely replaced by geometric constructions. Openwork shapes were created which either enclosed or implied spatial extensions, and the implications of this new treatment are even today still

being examined and developed. The traditional distinction between painting and sculpture had also broken down, and the introduction of scrap materials, of new synthetic media which were first made for industrial use, and the use of industrial techniques such as welding, had all had their impact on sculptors even before 1945. The Spanish-born Julio Gonzalez (1876–1942) had settled in Paris in 1900 and he pioneered the use of forged and welded iron for sculpture as early as 1928 when, at Picasso's request, he began working in iron and initiated Picasso into the traditional Spanish metal-working techniques that he himself had learnt from his blacksmith father in Barcelona. Both Gonzalez and Picasso produced iron sculpture and their example inspired a younger generation of sculptors such as César (1921–98), who began making iron sculptures in 1952, and whose winged figures make an interesting parallel with some of Chadwick's work. Nearer home, Reg Butler, who had worked as a blacksmith 1941–5, began making forged iron sculptures from 1949. Those were seen and admired by Chadwick at Butler's first Hanover Gallery, London, exhibition in 1949. Direct carving, as we shall see from Chadwick's work, no longer enjoyed its former pre-eminence as the purest form of sculpture. The old 'truth to materials' ethos no longer held sway. Sculptors are by nature sturdy, independent characters who soon react against their mentors and pursue their own ideas. This is not to say that they are impervious to the discoveries of their older colleagues, but simply that they will not be content merely to imitate them unquestioningly. Chadwick's career certainly exemplifies this.

A decisive break came in March 1946, when Chadwick and his family moved from London to Fisher's Cottage, near Edge, Stroud in Gloucestershire. He felt confident enough to set himself up as a freelance designer and for some five years, until 1952, he produced textile, furniture, and architectural designs. A year later, in April 1947, Chadwick moved again, to Pinswell, Upper Coberley, near Cheltenham, an isolated cottage without electricity, telephone, or water (except for a nearby well), where living was extremely cheap, if somewhat spartan. The Chadwicks had no car, and learnt to be very self-sufficient.

Although Rodney Thomas did not provide Chadwick with any contacts of use to him either as designer or sculptor, he did sow the germ of an idea that Chadwick was later to develop as mobiles. Thomas, who had originally wanted to be a painter (he studied at the Byam Shaw School and at the Slade), was always interested in the shape of a building, and combined an acute visual sense with sound engineering and structural awareness. He had begun in 1945 to make balanced shapes out of thin

bent aircraft plywood, with one beam or shape rocking in equilibrium on another. Chadwick took this idea but suspended thin two-dimensional shapes in a state of balance. He made his first mobiles in 1946. They were constructed of balsa wood and aluminium wire, and moved in the slightest current of air.

Rodney Thomas and Chadwick were both emphatic that they knew nothing of Alexander Calder's work, and had developed their ideas quite independently of him.[13] While it is possible that Chadwick saw mobile sculptures in New York when training for the Fleet Air Arm, his own mobiles were first thought of as part of design rather than as sculpture *per se*. Chadwick's early mobiles were conceived primarily as attractive features for exhibition stands, such as those for the Aluminium Development Association's stand at the Builders' Trade Fair of 1947, or the Morris Furniture Company (of Glasgow) stand at the British Industries Fair the following year. The ADA mobile was admired by Basil Spence, and through friends in Gloucestershire (Diana and Oliver Lodge) Chadwick

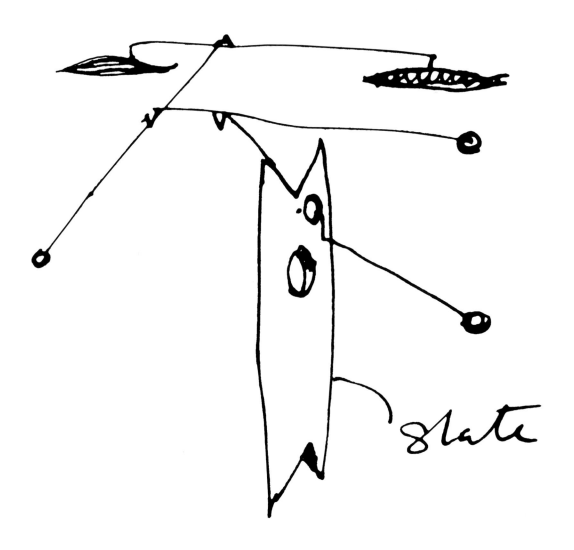

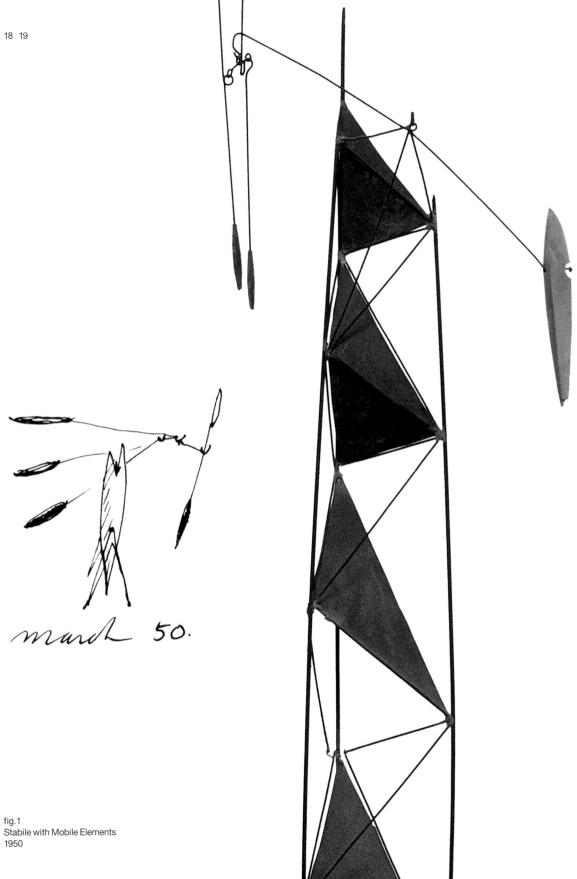

fig.1
Stabile with Mobile Elements
1950

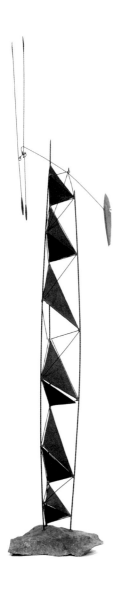

was introduced to the architects Jane Drew and Maxwell Fry (who had worked with Gropius in the late 1930s). His work also attracted the attention of the art dealers Charles and Peter Gimpel, of Gimpel Fils, and in August 1949 he showed a small mobile in the window of their South Molton Street gallery. This was followed by his first one-man exhibition there in June 1950, where he exhibited fourteen mobiles.[14] The largest of these was 7ft (2.1m) overall with a diameter of 8ft (2.4m): *Slate shape and iron rods* (no.38 in the Gimpel catalogue). Others were made of wood, slate, and copper shapes, with iron rods. At first, Chadwick thought of his mobiles as architectural constructions rather than as sculpture, but the dealers considered them to be sculpture. Rodney Thomas's ideas about mobiles had reawakened Chadwick's latent desire to make things with his hands, and led him on to create sculpture.

Stabile with Mobile Elements 1950 (fig.1), 50in (127cm) high, is one of the few surviving works from this early period, and is constructed of brass wire, copper and brass triangles, set in a rock fragment base. It consists of a triangular-shaped wire frame with triangular plates, set diagonally, acting as stiffening supports within the three upright rods (the 'stabile'), the whole supporting a delicately constructed mobile that pivots, slightly off-centre from the apex. Light is reflected off the interstitial plates, and the mobile, with its three vertical elements, provides a three-dimensional movement in space. It was first exhibited in 1952 as 'Space Frame in Green' – a reference to the green oxidisation of the copper and brass triangles. In some mobiles of this date, Chadwick used clear primary colours – red, blue and yellow – for his shapes, in others, such as *Stabile with Mobile Elements*, he leaves unpainted the natural colour of the metals.

Chadwick's career advanced dramatically in 1950, for in March Jane Drew commissioned him to make a mobile for the Tower of her Riverside Restaurant and Misha Black asked him to construct a stabile which was to be put in the garden of Misha Black and Alexander Gibson's Regatta Restaurant, both on the South Bank site of the Festival of Britain.[15] An important consequence of these commissions was that Chadwick realised he had to learn how to weld. Up to now, most of his mobiles had been relatively small in scale. Now that the scale was much enlarged he had to confront new structural problems, not least those of increased weight and thicker materials. The stabile, *Cypress* 1951 (fig.2), for the Regatta Restaurant garden, was 13ft (4m); the maquette for this work, *Stabile with Mobile Elements (Maquette for 'Cypress')* of 1950 (fig.3), is a mere 26in (66cm) high. (A second maquette for the final version was 4ft [1.2m] high.) Almost without exception, the titles Chadwick gave to his early mobiles were laconically descriptive: 'mobile' or, occasionally, 'stabile with mobile elements'; there were no overt associational references, but now, in this

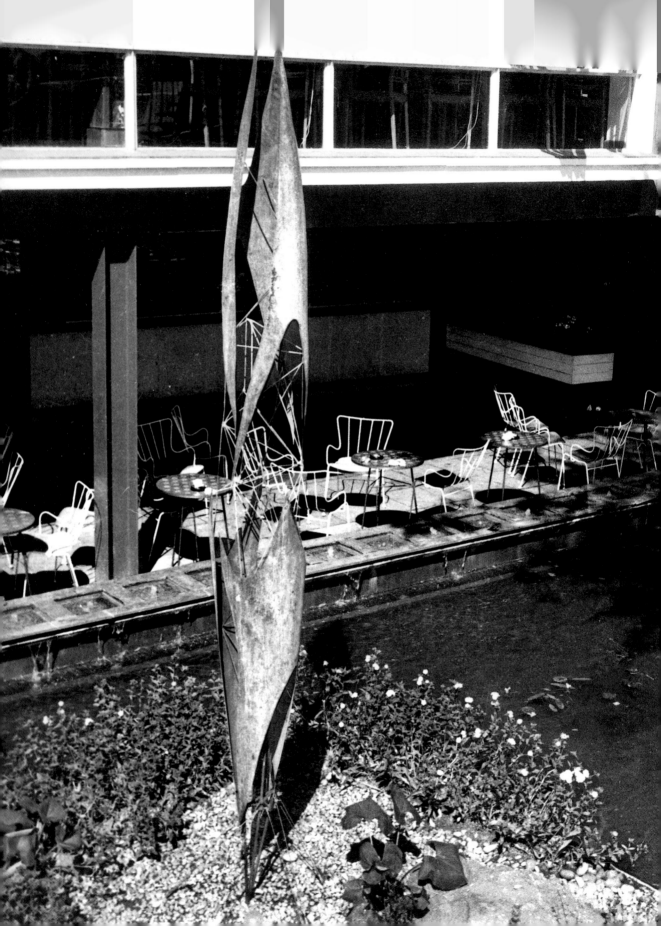

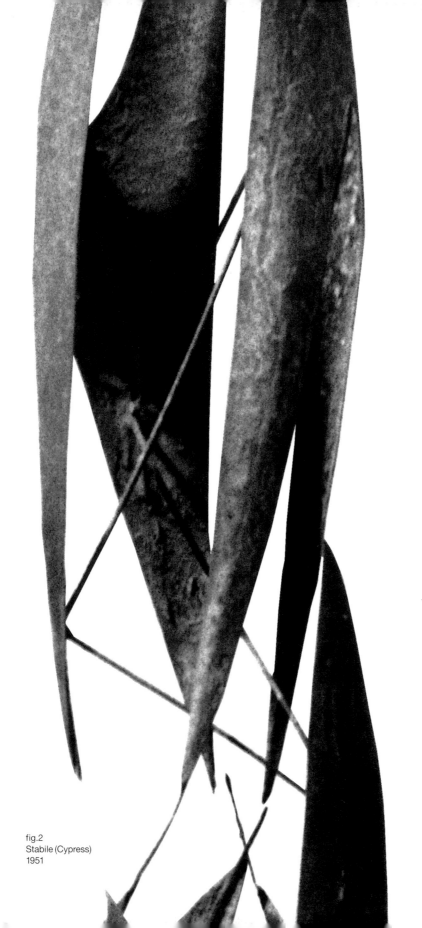

fig.2
Stabile (Cypress)
1951

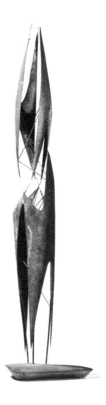

fig.3
Stabile with Mobile Elements
(Maquette for 'Cypress')
1950

and other public commissions, he uses titles that suggest or refer to specific natural forms.

In the summer of 1950 Chadwick took a four-week course in welding at the British Oxygen Company's Welding School at Cricklewood. He learnt how to weld copper, which is a more difficult process than the acetylene gas welding method used for ferrous metals. Arc welding produces the best results for non-ferrous metals. Apart from *Stabile (Cypress)* 1951, composed of copper sheet and brass rods, Chadwick had preferred to use oxy-acetylene welding (or gas welding), a process in which acetylene gas is mixed with oxygen to produce a flame which burns at a very high temperature (3,300°C). To produce a welded iron joint, for example, a stick of the same metal is introduced into the gap and is then melted by the gas flame, causing it to fuse with the surrounding metal to form a homogeneous join or surface. It is a time-consuming process: a single weld, or 'node', can take up to twenty minutes to complete satisfactorily. It is also physically demanding, since a section of sculpture may require two or three hours' continuous work to complete, as the metal must not be allowed to cool. Chadwick worked standing and this was eventually to be bad for the circulation in his legs. Characteristically, he always insisted on mastering new techniques for himself, and would not delegate important stages of his work to studio assistants.

Stabile (Cypress), for which the first maquette was made, was a space-frame construction, rigid in all directions, made from brass rods, with four sail-like curved copper sheets or membranes, grouped into two main elements to form a broadly elliptical composition. The whole was supported on splayed iron struts welded to a base plate. All these features appear in the first maquette, and Chadwick was able to enlarge the design without losing any of the elegant delicacy of his original construction. Many years later he recalled that Misha Black had asked him not to place a mobile on top of the stabile, and Chadwick was happy to oblige: 'at this point, I was able to...stop worrying about being a person who made mobiles, and to think I could be more of a static sort of sculptor.'[16] There is more than a passing affinity between his *Stabile (Cypress)* and the 300-ft Skylon by Powell and Moya, which was such a dramatic feature of the South Bank exhibition site.

In fact, the transition was not quite so clear-cut as this recollection suggests, since in 1951 he created a mobile, *Dragonfly* (fig.4), that has to be suspended from a ceiling, and a magnificent 7ft 6in (2.3m)-high iron and copper stabile/mobile, *Fisheater* (fig.5, pl.1). These two works can now be seen as a triumphant climax to this early phase of Chadwick's career as a sculptor, and both make specific reference to the natural world of insects and fishes. There are similarities in subject-matter with the series of

fig.4
Dragonfly
1951

fig.5 (and pl.1)
Fisheater
1951

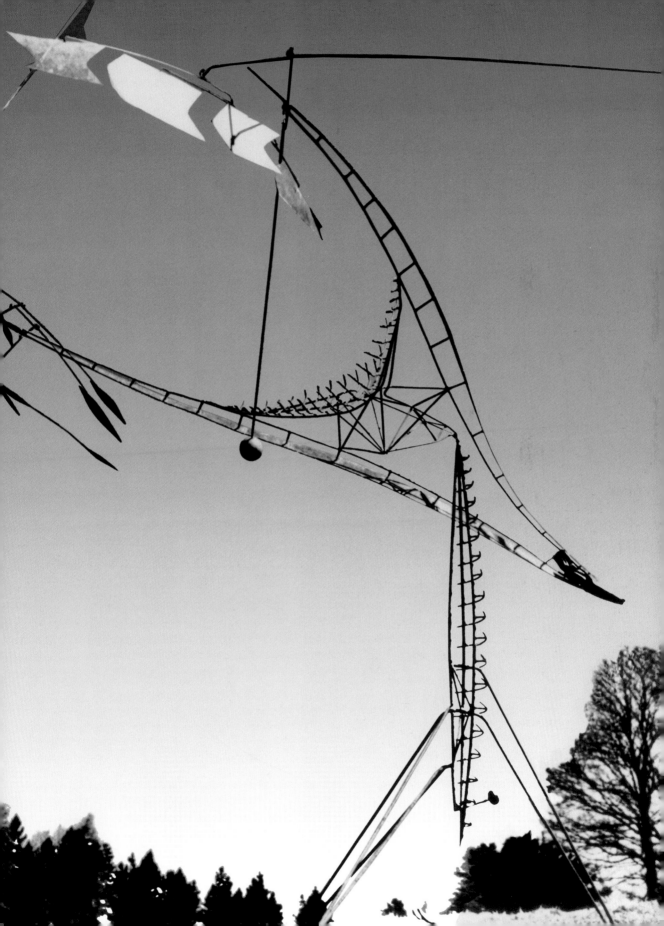

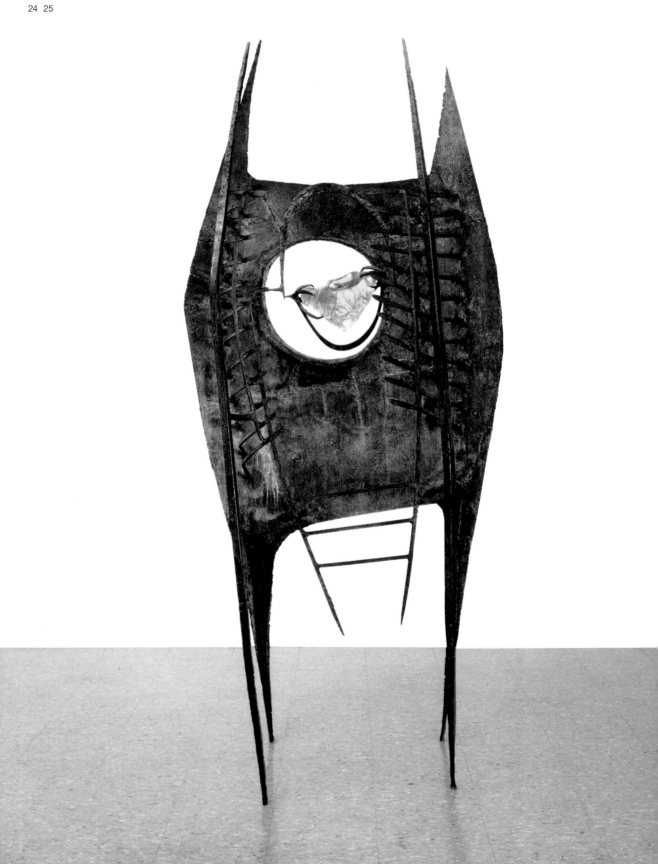

paintings on thorn and insect themes by Graham Sutherland of the same period.[17] *Fisheater* had been commissioned by the Arts Council of Great Britain for £250, and *Dragonfly* was purchased for 50 guineas by the Contemporary Art Society and presented to the Tate Gallery. Technically, Chadwick has exploited the rich textural effects produced by the welded nodes of melted metal left at each end of the joins on, for example, the open-work mesh of spiky ribs and long lateral rods which form the legs and spine of *Fisheater*. His architectural training and sense of structure assert themselves in both works. The central spine of *Dragonfly* is daringly cantilevered out from a spiked rod, and is composed of a slender lattice-work of welded rods. The heavier winged section is balanced by a long weighted 'tail', and the fish-like elements of the mobile are counterpointed by elongated triangular plates through which Chadwick has randomly drilled holes; the whole structure has an airy delicacy that befits the subject.

Chadwick originally coloured the arms of *Fisheater* purple, leaving the big and small copper fishes in their natural verdigris-green. Now, stripped of colour, it relies for its effect on the purely sculptural qualities of form, texture and the encompassment of space, and Chadwick considered it 'much simpler to have it all black, [as it] forms more of a unity.'[18] He also felt that he had taken the suspended mobile format as far as he could, and in making *Fisheater*, he had to tackle the problem of supporting a large mobile on some sort of framework or pylon:

> so, in doing that, I realised that, in fact, the actual structure itself was interesting me, because I'd learned to weld, by this time, in order to make bigger things … I thought 'All right, I'll concentrate on that, and I'll see what I can do with it; … I'll let them be something in their own right.'[19]

This essentially heuristic approach to sculpture was central to Chadwick's method of working, for although *Fisheater* is a large and complex work for which he had to make a few preliminary drawings, there are no sets of detailed working drawings for this or his other mobiles. This is in complete contrast, for instance, to Naum Gabo's precision engineer's drawings for his sculptures. For Chadwick, the creation of a sculpture was a controlled process of trial and error, beginning with small pieces and building them up into a structure that will balance on a fulcrum. When making *Fisheater*, he had to place pieces of concrete on the 'tail' of the main arm until he achieved the desired equilibrium.[20]

By now, Chadwick was beginning to evolve a distinctive personal vocabulary of welded iron shapes, and the process is carried a stage further in *Inner Eye (Maquette III)* 1952 (pl.2), where he introduces a chunk of glass (a molten gobbet of glass or paraison) which is held in a suspended pincer. This maquette is one of five he made preparatory to the large *The Inner Eye* 1952 (Museum of Modern Art, New York), which is 7ft 6in (2m 29cm) high (fig.6). Here, a spiked shield-like shape is pierced by a

fig.6 (and detail overleaf)
The Inner Eye
1952

glass.

co...
light.

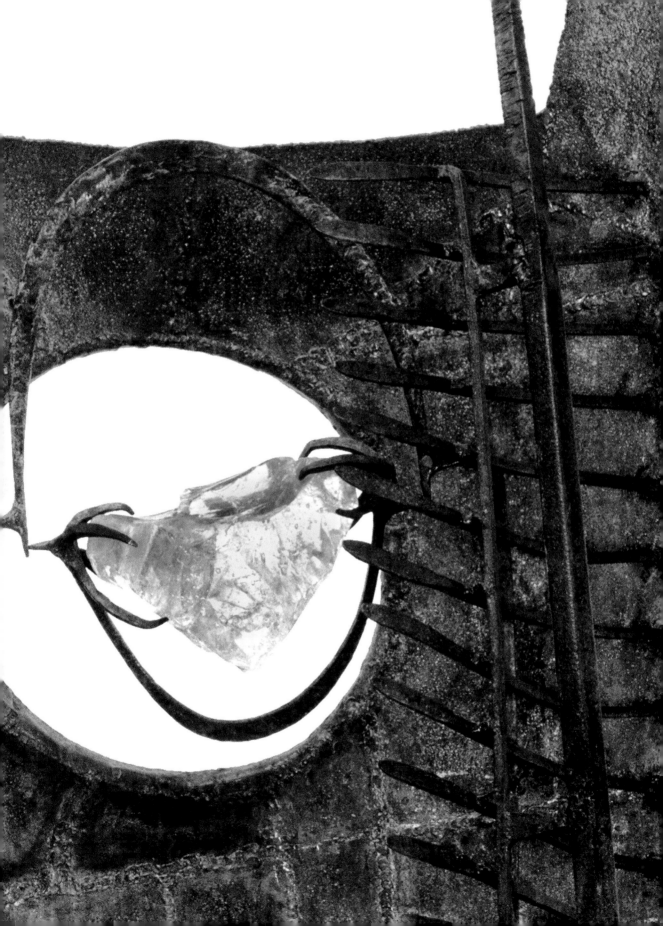

large circular hole – an eyehole – against which is set a delicate mesh of rods supporting a horseshoe-shaped revolving claw that grips the crudely formed glass 'inner eye'. Chadwick exploits the contrast between the solid iron matrix and the translucent gobbet of glass, which gleams and refracts the light. Of the idea behind *The Inner Eye*, Chadwick recalled that:

> I had this memory of a dream, where I'd seen this sort of thing in a dream. I'd seen I think it was a fish, actually, and in the middle of the fish were these pieces of crystal. That was the origin of it, a dream.[21]

He had earlier explored the possibilities offered by pivoted metal elements, set within a frame, in *Bullfrog* 1951 (Pembroke College, Oxford, fig.7), and *Barley Fork* 1952 (formerly Nelson A. Rockefeller Collection, New York). Here, too, Chadwick explores the interaction between inner and outer forms, a theme Henry Moore had earlier tackled in his helmet heads. Although all these sculptures are essentially open-work meshes of rods and curved shapes, they prepare the way for more solid structures.

'So when it came to the Unknown Political Prisoner Competition, I made a frame, but filled it in solid, so it was solid and that was the first solid sculpture I'd made. Well, not quite the first, but the first time I showed such a work.'[22] The *Maquette for Unknown Political Prisoner* 1953 (fig.8) is in welded iron, and consists of five lozenge-shaped spiky forms. Even in a maquette 17in (43cm) high, the simple monumentality of the piece can be sensed. The Unknown Political Prisoner International Sculpture Competition was sponsored by the Institute of Contemporary Arts in London, and launched in January 1952. Reg Butler won the first prize of £4,525, and Chadwick won an honourable mention and a £250 prize.

Chadwick insisted that there were no literary associations in his mind when making the sculpture: for him, the technical problems of welding these spiked shapes was all-important. Nevertheless, there is a clear reference to a solitary figure enmeshed within a hostile palisade and the sculpture works on two levels: the formal and the symbolic. By this time, Chadwick was disillusioned by left-wing politics, and abhorred the evils of totalitarianism whether practised by the Right or the Left.

Almost contemporary with the Unknown Political Prisoner maquette is *Idiomorphic Beast* 1953 (Bristol City Art Gallery, fig.9), where Chadwick develops a new technique. *Idiomorphic Beast* is constructed from an elaborate and carefully crafted web of welded rods which form triangular units that are joined together at various angles to express the planes and sharp contours of its body, the whole supported on four thinly tapered forged legs. The beast's back has been left smooth, for the interstices of this web are filled with 'Stolit', an industrial artificial stone compound of gypsum and iron powder that is applied like wet plaster and which, on drying, sets glass-hard. It can then be worked and chased, coloured, or, more usually,

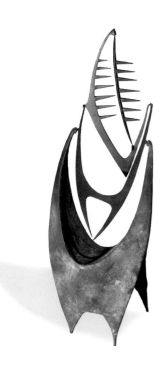

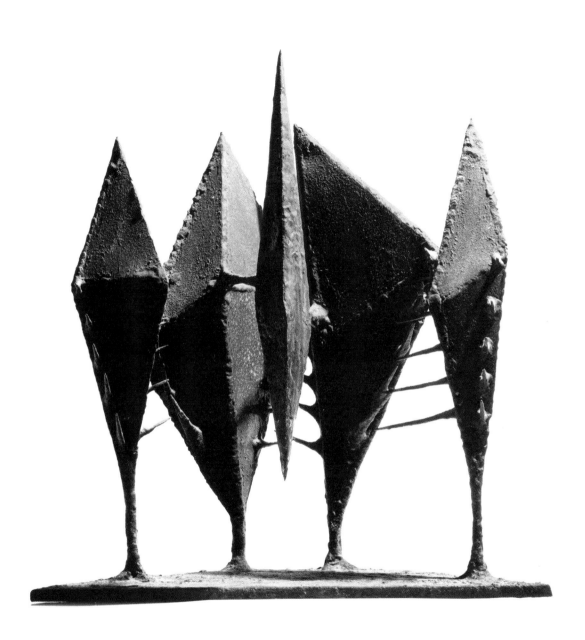

fig.7 (left)
Bullfrog
1951

fig.8 (and detail overleaf)
Maquette for Unknown
Political Prisoner
1953

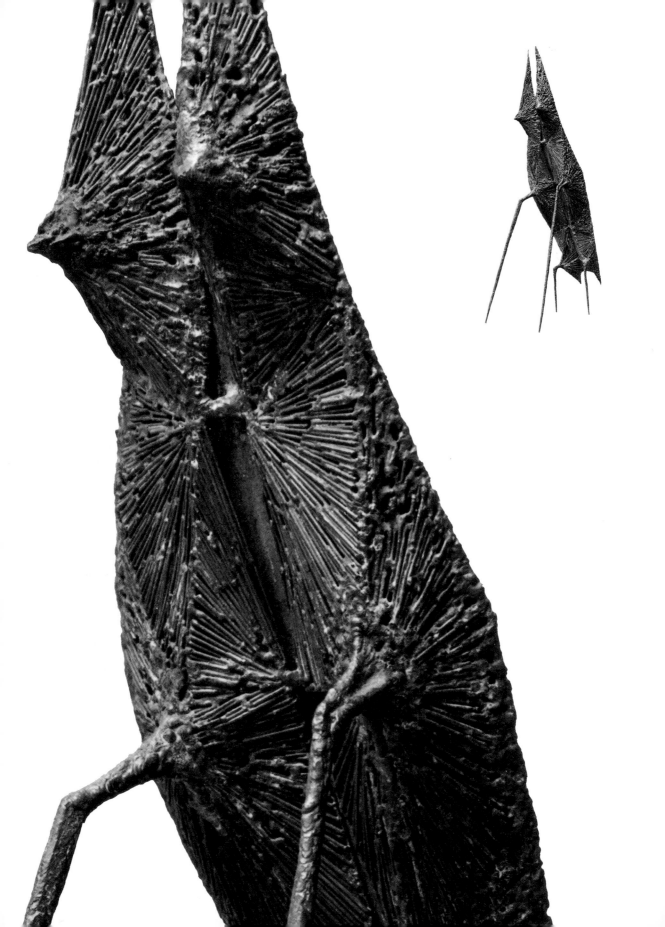

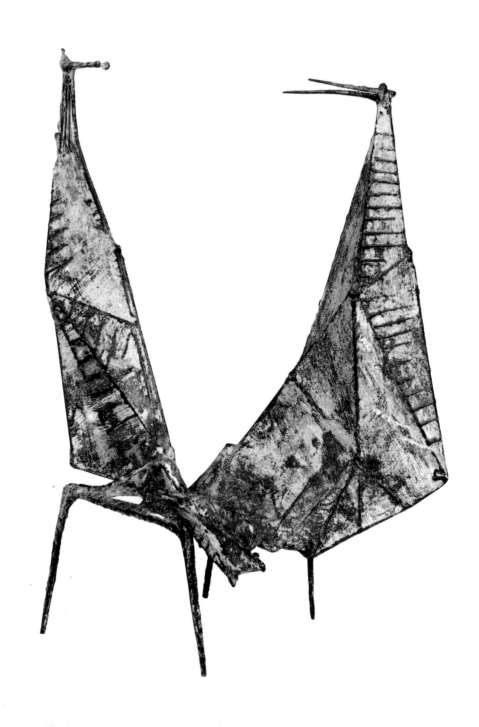

fig.9 (left)
Idiomorphic Beast
1953

fig.10
Conjunction
1953

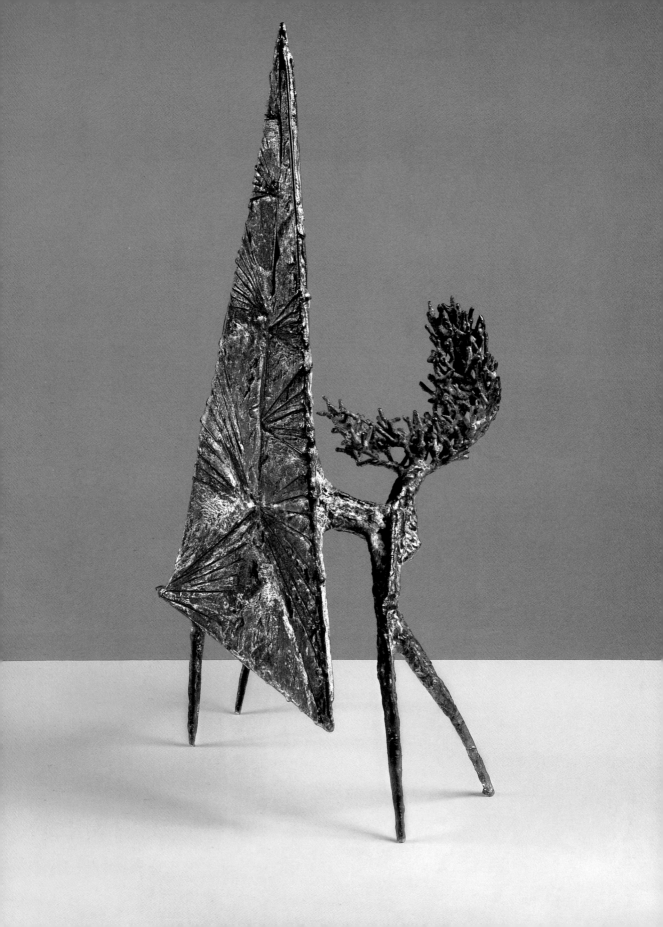

left to weather. The iron armatures rust and expand on contact with the moisture absorbed by the Stolit so that straight profiles become distorted with the passage of time, particularly if the sculpture is left in a damp environment, and, worse still, the Stolit crumbles and disintegrates. The ribbed texture produced by this method imparts a fossilised look to the sculpture that suggests some skeletal prehistoric creature.

The construction of these armatures of linked tetrahedrons, which are then filled in with compound over a base of expanded polystyrene foam (Chadwick used first coke, then replaced polystyrene with expanded metal mesh as a support for the Stolit), is a laborious, time-consuming method, and has the disadvantage that copies cannot be made. To make another version meant starting from scratch, and in the process Chadwick would introduce modifications and variations that resulted, in effect, in a totally new work of art. More problematic was the fragile nature of sculptures made by this method, and the fact that they were easily damaged when transported to and from exhibitions. In order to secure a more durable end product, Chadwick began in the 1950s to make bronze casts of his constructed sculptures. The principle of 'truth to materials' so dear to the avant-garde sculptors and carvers of the 1930s, like Moore and Hepworth, was no longer adhered to, and by casting in bronze, not only was a more permanent sculpture obtained but strictly controlled limited editions could also be made when required, a reversion to a more traditional practice.

Idiomorphic Beast, with its bat-like avian form, is as its name suggests peculiar to itself. It is also testimony to Chadwick's abiding roots in the natural world. For as a schoolboy he had often wandered alone across Barnes Common, observing and enjoying the country and riverside. He had happy childhood memories of holidays in Scotland (his mother was of Scottish descent), and he considered himself a countryman: only economic necessity kept him in London. As we have seen, as soon as he had achieved a modest, if uncertain, degree of financial independence, he escaped into Gloucestershire, which was to remain his home county.

Having established for himself a sculptural technique, albeit an arduous one, Chadwick began to create other fantastic beasts and groups of strange, allusive beings, one of which, *Conjunction* 1953 (fig.10) in iron and composition, must do duty for a whole menagerie of creatures (e.g. *Bird* 1956, fig.12). Two bird-like forms appear to share the same roosting branch and to be engaged in a courtship. This sculpture also reveals a witty playfulness that often lies just below the surface of Chadwick's work. A sly humour enlivens the 'encounters' and 'conjunctions' that frequently recur as themes in his sculpture of this period and subsequently. Abstract shapes they may be, but as he himself admitted, although he begins by thinking in terms of pure shapes, he 'can't resist adding something'.

fig.11
The Seasons
1955

fig.12
Bird
1956

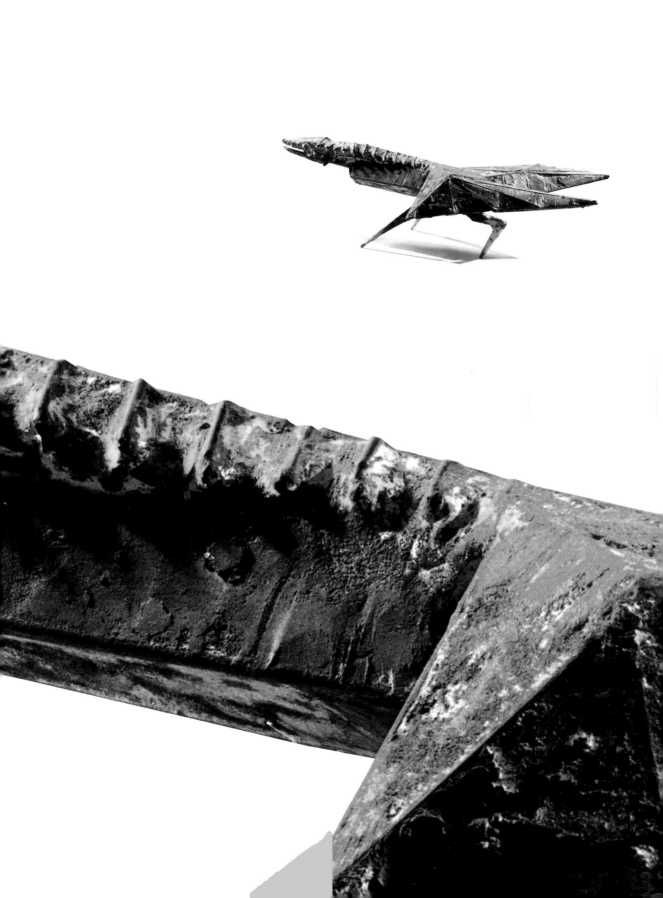

Three sculptures of 1954–5 show Chadwick's fertile imagination at work on developing these semi-abstract themes to which 'something has been added': *Maquette for The Stranger* 1954, iron and silver (fig.13), *The Seasons* 1955, iron and composition (fig.11) and *Untitled* 1955, iron and glass (pl.3). The first of these, one of several on the 'Stranger' theme, again reminds us of some primeval, pterodactyl-like creature, with leathery wings outstretched and a vestigial, cruel beak. Even the title is evocative of an alien creature from a remote past. Here, too, Chadwick experiments with juxtaposing dull, unpolished black metal with a brightly gleaming silver slab inset on the 'chest' of the bird, and continues the 'Inner Eye' concept of contrasting materials. Contrast of a different kind is the key to *The Seasons*, a sculpture that was made for the Contemporary Art Society's exhibition of that name, in which it was shown in 1956 at the Tate Gallery.[23] A gnarled, leafless tree form is set against a soaring abstract pyramidal shape, which blossoms triumphantly in full vigour. A similar juxtaposition occurs in *Untitled*: a tall skeletal figure, with a ribcage of horizontal, rough-finished rods, sprouts a curious octopus-like growth from its midriff, and the 'head' of the figure is surmounted by a tangled mop of short spiky tufts.

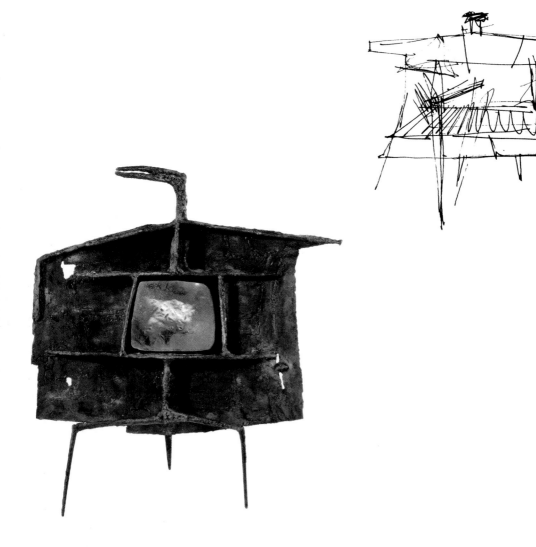

July 54

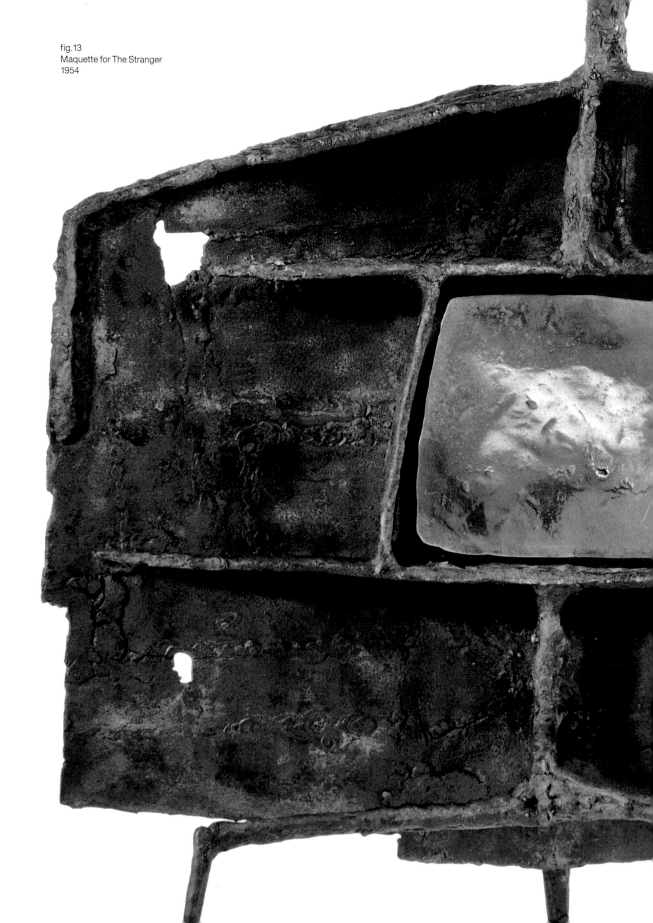

fig.13
Maquette for The Stranger
1954

The Venice Biennales of
1952 and 1956: A Turning Point

Chadwick first appeared before an international audience in 1952, when the British Council invited him to contribute four sculptures and four drawings to a group show of eight younger British sculptors at the XXVI Venice Biennale of that year.[24] They were all under forty, and after Moore's success in winning the International Sculpture Prize at the 1948 Biennale, and Hepworth's retrospective at the 1950 Biennale, the organisers of the British Pavilion were keen to show off a younger generation of British sculptors so as to emphasise that sculpture once again flourished in this country. In his introduction to the catalogue for the exhibition, Herbert Read made this point, but also stressed their individuality; they were not members of an organised group. He also coined the phrase 'the geometry of fear' to describe what he felt, as an admirer of C.G. Jung, to be the workings of a collective unconscious.[25] These artists, besides exploiting technical innovations, had turned away from the serene classical imagery of an earlier age:

> These new images belong to the iconography of despair, or of defiance; and the more innocent the artist, the more effectively he transmits the collective guilt. Here are images of flight, of ragged claws … of excoriated flesh, frustrated sex, the geometry of fear.

Seen in the context of the horrors of the Second World War and of its aftermath, Read, who had known the trauma of trench warfare in the First World War, sought with poetic insight to suggest that the 'innocent artist' conveyed such a mood all the more powerfully for not having consciously sought to do so. One must also remember that Read had written in strong support of Surrealism during the mid-1930s, and considered it particularly congruent to the English literary tradition, going as far back as Shakespeare, and flourishing in the work of William Blake and Coleridge. British art was emerging from a period of neo-Romanticism, best typified by Sutherland's evocative Welsh landscapes of 1939–40, the intense pastoral idylls of John Minton, and David Jones's lyrical Celtic fantasies. Even Chadwick's *The Seasons*, with its menacing, organic fecundity, still carries a neo-Romantic charge.

The phrase 'geometry of fear' became a hackneyed critical cliché, and

Chadwick certainly did not feel that it explained his own work; Read, when writing about Chadwick six years later, qualified his theory and spoke of a 'demonic force ... pent up in the unconscious ... [which] when it is released, can assume significance, universal meaning, as works of art.'[26] Chadwick had himself said, four years earlier (in 1954):

It seems to me that art must be the manifestation of some vital force coming from the dark, caught by the imagination and translated by the artist's ability and skill ... When we philosophize upon this force, we lose sight of it. The intellect alone is still too clumsy to grasp it.[27]

Read's comment that the British sculptors shown at the 1952 Venice Biennale were each distinct artistic personalities is true, but there were some similarities. Geoffrey Clarke (b. 1924) was working in iron by 1950, and his *Woman* 1952 (Tate) is a spindly figure comprising a ribcage and spine, which is more akin to Giacometti's skeletal approach; on the other hand his wall sculpture, *Spirit of Electricity* 1957–9 (Thorn House, London), in welded iron, has some affinities with Chadwick's use of welded iron rods, but is conceived in more severely geometrical terms.

Kenneth Armitage (1916–2002) was at this stage working in bronze, and his sculptures emphasised the block-like characteristics of the human figure. Although *Figures in a Wind* 1950 (Tate) anticipates a theme later explored by Chadwick, their approach is dissimilar: Armitage fuses his figures together and they appear as if sucked up by the wind rather than having their individual shapes defined by windblown draperies as in Chadwick's later work. Both Armitage and Chadwick used spindly legs and an inverted triangle or rectangular block notation for the heads of their figures (as in Armitage's *Diarchy* and *Triarchy* series of 1957, and Chadwick's *The Watchers* 1960), but Chadwick, as we shall see, developed and codified this convention in a highly stylised, distinctive way.

Robert Adams's (1917–84) steel and iron sculptures of this period were much more abstract, depersonalised spiked shapes than Chadwick's, and Robert Clatworthy (b.1928) explored, in almost an expressionist manner, animal vigour in a series of *Bulls*, which are notable for their chunky forms and massive modelling. Bernard Meadows (b.1915) also went through an expressionist phase in the mid-1950s, sculpting birds, fish and animals which carry menacing overtones. William Turnbull (b.1922) was fascinated by the totemic quality of sculpture. He worked mainly in bronze, and an early *Mobile/stabile* of 1949 (Tate), which consists of thin rods radiating at right angles to a central rod, is closer in spirit to Paolozzi's *Forms on a Bow* of 1949 (Tate), but more aetiolated.

Four years after his debut at the XXVI Venice Biennale, the British Council chose Chadwick to represent sculpture at the XXVIII Venice

fig.14 (below)
Installation photograph
of Venice Biennale
1956

fig.15 (overleaf)
Installation photograph of
Venice Biennale 1956, showing,
from left to right, *Idiomorphic
Beast* 1953, *The Seasons* 1955,
and *The Inner Eye* 1952

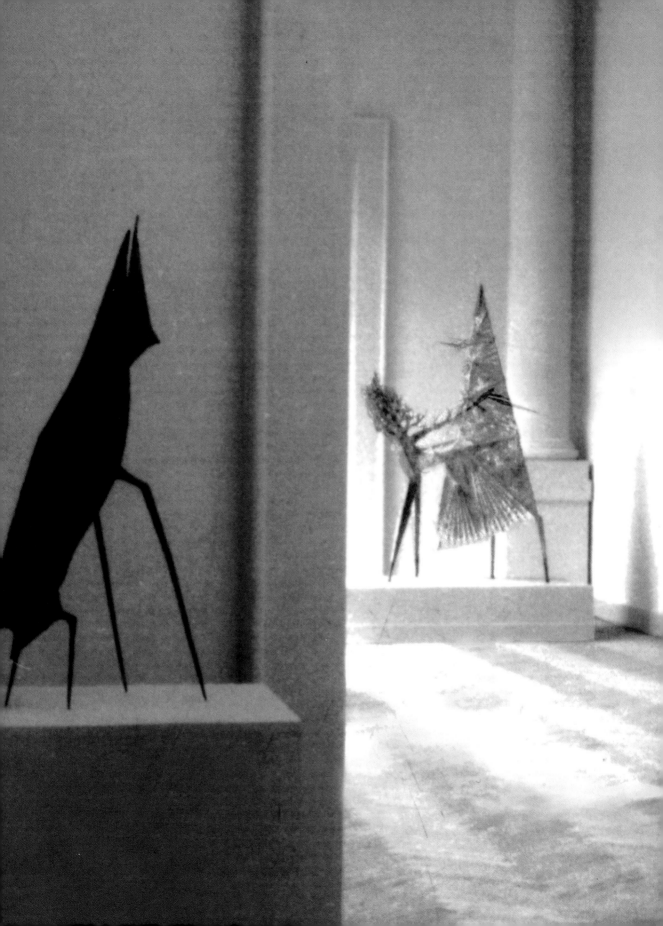

Biennale in 1956, displaying his work in one of the rooms in the British Pavilion. There were nineteen of his sculptures executed between 1951 and 1956, including such major pieces as *The Inner Eye* (Museum of Modern Art, New York), *Idiomorphic Beast* (fig.9) and *The Seasons* (fig.11), and *Teddy Boy and Girl* (fig.17). The sculpture was complemented by a selection of twenty pen and wash drawings. Although many of the sculptures and drawings were lent by private collectors, the Venice catalogue, and those for the subsequent tour of European cities, show not only how many prominent private collectors in Europe and America had acquired Chadwick's work, but also just how many important public museums worldwide had bought his work for their permanent collections. Nevertheless, it still came as a surprise to the art world when Chadwick was awarded the International Sculpture Prize at the age of forty-one. He was the youngest post-war recipient of the prize, a relative newcomer as a sculptor, and he was himself astonished at his unexpected success.[28] Giacometti had been expected to win, and some critics, like David Sylvester, who wanted Giacometti to win, were resentful of Chadwick's success. Even the fair-minded Denys Sutton, while acknowledging Chadwick's undoubted potential, felt that the convention of honouring a lifetime's achievement should have been adhered to.[29] The British Council was at that time constantly under attack from the Beaverbrook press for 'wasting' taxpayers' money on 'ridiculous' modern art, and thus there was an added political dimension on the home front that had led senior British Council figures to question their own Fine Art Department's wisdom in choosing Chadwick and other young, unconventional British artists to represent their country. Chadwick's success fully vindicated their courageous choice. French and German critics, and some of Chadwick's fellow artists, acclaimed his success, as did Alan Bowness, who wrote:

> Chadwick has been one of the revelations of the Biennale. Quite apart from the distinguished and highly original quality of his imagination, it is the beauty and sensitivity of execution that impresses. He may make use of the 'creative accident', but the very sureness of his control makes most modern sculpture look simply incompetent by the side of his work. This Biennale award marks the emergence of Lynn Chadwick as a figure of international artistic importance.[30]

It was a *succès d'estime*, for the prize money of 1.5 million lire (then worth £864), although very welcome, was comparatively modest.

Teddy Boy and Girl 1955 (fig.17), with its reference to the flamboyant neo-Edwardian dress adopted by young working-class men and women at the time, is a development from the dancing figures that Chadwick had begun in 1954. Cast in bronze from an iron and composition original, it is a playful comment on the frenetic dancing style of the period. Chadwick

fig.16 (and detail overleaf)
Beast VII
1956

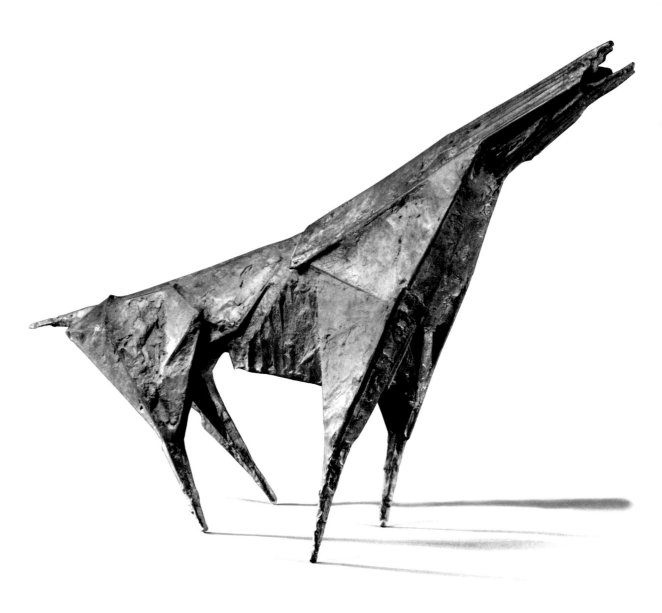

April 58 Beast XV

LukS 42cm

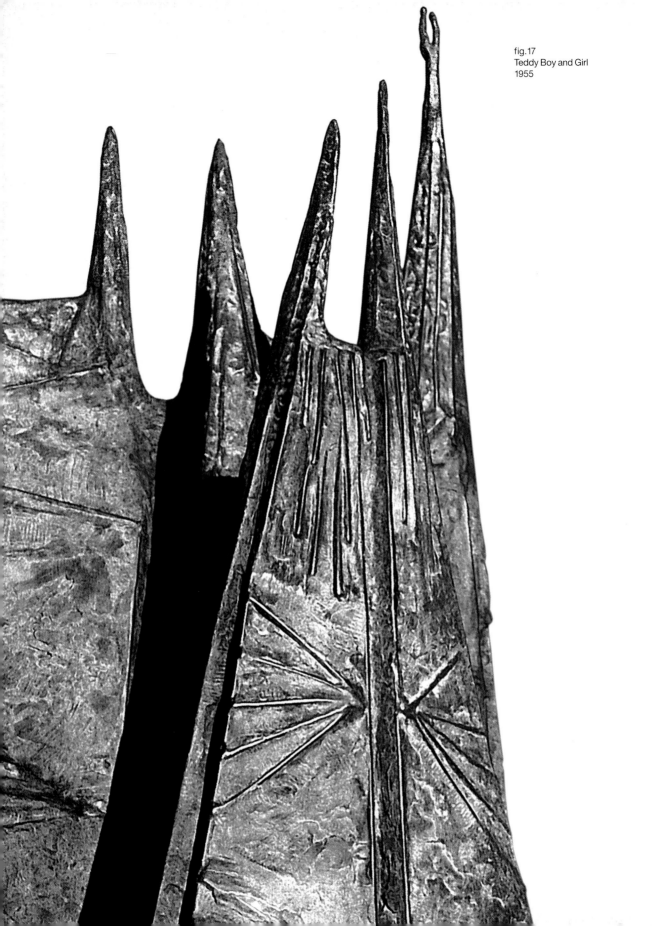

fig.17
Teddy Boy and Girl
1955

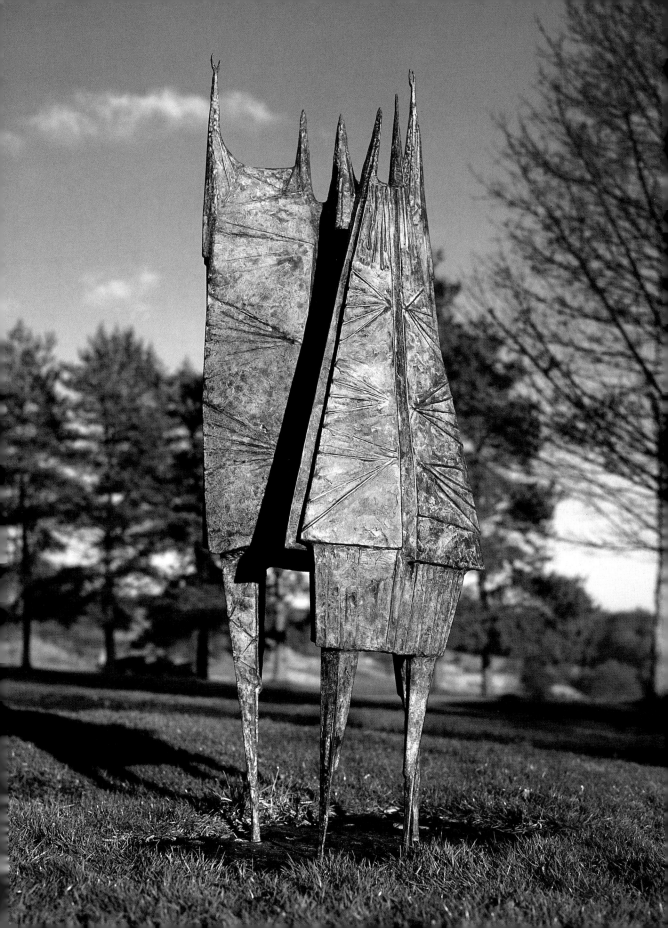

wittily contrasts the chunky shape of the male figure, with vestigial arms upraised, with the slim, pyramidal shape of the young woman, creating a formal and sexual tension between the two. Both bodies are bisected vertically by a deep indentation back and front, which subtly defines and suggests their volume, especially the sensuous curve that describes the girl's spine and buttocks. The surface textures are also emphatically distinct: the young man's exaggeratedly long jacket is described by vertical striations, she wears a clinging dress picked out by interlocking triangles. The couple's gyrations have been caught and frozen, as if in a snapshot.

Dancing Figures (Two Dancing Figures) 1956 (pl.4) continues the *Teddy Boy and Girl* theme, but is now a more generalised treatment of unclad figures in motion. The two figures move in counterpoint, echoing each other's stance, but with subtle variations. Chadwick said of his work that he did not like it to have a static quality or 'attitude' (a word that often occurred in his conversation):

> I would call it attitude, you know, the way that you can make something almost talk by the way the neck is bent, or the attitude of the head ... you can actually make these sculptures talk; they say something, according to the exact balance, whereas if they're absolutely straight ... well, I suppose that is saying something, too.

In *Dancing Figures*, the tilt of the shoulders and hips, the angle of the heads, here merely indicated by two parallel spikes that do duty for a neck, the set of the legs of the two bodies, all these elements impart a dynamic to the group as a whole. In the working model for the bronze edition of two, the Stolit compound has weathered to a beautiful soft honey-brown, and the model has never been shown outdoors because it would suffer from the elements.

Beast VII, 1956 (fig.16, working model for bronze edition of nine) is, as its title records, the seventh in what was to become a prolific series of over a dozen *Beasts* done in as many years, the first of which was made in 1955 and shown at the XXVIII Venice Biennale of 1956. Chadwick has recorded by quick pen sketch in his Workbooks a similar work of about the same date, and he used drawings of this kind for purely record purposes; they were done after the piece was made, and were not preliminary sketches for sculpture. He also executed drawings at the request of collectors, usually simple pen and ink sketches, with very little cross-hatching, and sometimes with a wash of colour. Perhaps surprisingly, he found drawing more tiring to do than sculpture: he explained that for him it required more concentration and he could usually only do it for an hour or so.

Beast VII is typical of Chadwick's ability to create a sculptural metaphor for the essence of animality. Although superficially an abstraction, in that it

fig.18
Moon of Alabama
1957

does not represent a particular kind of beast, the sculpture pulsates with animal vigour as it stretches itself menacingly before us, hackles raised. It may be significant that in 1955 Chadwick visited Mykonos and Delos, and saw the much-weathered remains of the famous avenue of lions at Delos, that have been dated to the second quarter of the sixth century BC, which he much admired.[31] He also responded enthusiastically to the rugged vigour of the Easter Island figure he had first seen at the British Museum:

> I wish I could do something like that. It's part of a culture that was something unbelievable, and which has now disappeared into the Pacific ... the dignity of them.

And he made the point that monumental scale was not just a question of size. Chadwick's interest in so-called primitive art and archaic Greek sculpture was one that he shared with an earlier generation of sculptors such as Epstein and Moore, who visited the ethnographic collections in London and Paris with as much interest as those of the classical and later eras.

Moon of Alabama 1957 (fig. 18), for which Chadwick made five maquettes, is, at first sight, *sui generis* and without any obvious antecedents. Perhaps the nearest prototype is *Maquette for The Stranger* (fig. 13) of three years earlier, but while this work remains relatively two-dimensional, in *Moon of Alabama* Chadwick explores the possibilities of creating a facetted globular shape – a polyhedron – perched on three *pilotis* (to borrow Le Corbusier's architectural term for point supports). The exotic title was bestowed on the work after its completion, and Chadwick explained that he gave all his titles after, not before, a sculpture is made. That is to say, there are no conscious literary or other allusions at play during the conception of the piece.

Moon of Alabama reminds one of those evil-looking mines, horned with detonators, that were sown at sea and whose shape Chadwick may subconsciously have recalled from his Fleet Air Arm days as he worked on the maquettes. But he would almost certainly have denied any direct link: as in the *Unknown Political Prisoner* sculpture, he would have been concentrating on the technical problems inherent in fabricating *Moon*. Actually, Chadwick has said that *Moon of Alabama* 'was the origin of what we later called "The Beasts", because I had this "Moon of Alabama", and I cut it in half and put legs on it, you see ... and stuck the head on.'[32] He has also, of course, elongated the roughly circular form so as to create the body of the beast. This no-nonsense approach was typical of Chadwick's pragmatic way of working.

His working day followed a regular pattern:

I prefer to have a rather metronomic life – getting up at a certain time in the morning, going off [to his workshop] and starting work at eight o'clock – this is what I prefer to do. And then I get the whole thing sorted out in the morning, when I'm fresh. And in the afternoon, I just continue [after having lunched at the house]. It's easy. And sort of drift on in the afternoon.[33]

He had always been an early riser and went to bed by about ten. When he was still active as a sculptor, he told me:

I always feel I'm only just starting … just learning how to do it, never arriving … There's always something I must do tomorrow, must do this or that, I'm working towards some nebulous goal.[34]

Chance played a part, and sometimes Chadwick was surprised by an unexpected result: 'if it's good, fine; if it's bad, do something else.' He never had a problem of 'what to do next?', and did not become upset if he could not immediately resolve a problem: it sometimes took six months or a year for a solution to suggest itself to him. As his work developed, as he created a language, so he had to think how he could do, say, a sitting figure differently from the series which had gone before.

In September 1958, Chadwick moved to Lypiatt Park, near Stroud, a late-fourteenth-century house which had been altered and enlarged by Sir Jeffrey Wyattville in 1809, with further additions by Thomas Henry Wyatt in 1876.

He bought it for the price of an ordinary four-bedroom house and began to adapt this much-neglected 'Strawberry Hill Gothic' house to suit his needs, creating large airy rooms by taking down partitions and painting the interior white. His skills as a designer were exercised in creating magnificent new bathrooms and practical furniture for the large dining hall and kitchen, including a large seating structure in polished cast concrete for the dining hall. It is a magical house, and the extensive grounds have been sensitively landscaped and tended by him over the years to form an ideal setting for some of his sculpture. Gardening became for him a relaxation and reinforced his love of the country. As a result of his Venice Biennale success he began to be even more in demand, and attracted some public commissions.

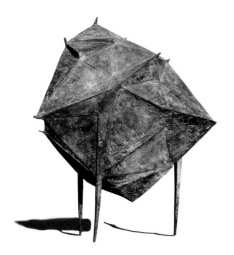

The R34 Memorial and the 'Manchester Sun'

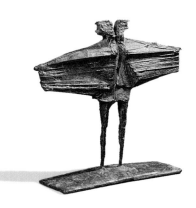

fig.19
Maquette for R34 Memorial
1957

Chadwick started to add wings to his dancing figures in the mid-1950s, and these were to become a lively feature of his work over the coming decade or so. In 1957 the Air League of the British Empire commissioned him to produce a memorial to commemorate the successful double crossing of the Atlantic by the airship R34 in July 1919. It was intended for the Long Haul Terminal Building at London Airport (Heathrow), designed by Frederick Gibberd and due to open in 1959. Sidney F. Sabin, a well-known London art dealer and Chairman of the R34 Memorial Committee, had proposed Chadwick. In July 1957 Chadwick sent Sabin an 18in (45.7cm)-high maquette (fig.19), which won approval not only from the Committee, but also from the then Minister of Transport and Civil Aviation, Harold Watkinson. Thus encouraged, Chadwick worked it up into a full-sized model, the 7ft 6in (2.3m)-high *Stranger III* 1959 (fig.20), as it was later called.

The genesis of this sculpture goes back to earlier works, such as *Maquette for The Stranger* 1954 (fig.13), already discussed, and *Stranger II* 1956 (fig.21), which is a massive winged figure with a beak-like head slightly turned to its right, the body supported on sturdy tapering legs. Chadwick's first idea for the R34 Memorial shows a two-headed winged figure with two huge, roughly symmetrical, bat-like wings, poised on three tapered legs. It might be more accurately described as two figures fused into one. The separate beaked heads, looking Janus-like to left and right, which symbolised the double transatlantic journey, were later welded into an elongated rectangular shape, set at an angle, as if looking out across a space; these fused well with the massive wings, which were themselves modified into a truncated pyramidal form on the left balanced by a shorter, squarer wing on the right. Although commemorating flight, the sculpture radiates an aura of implacable power. There is a sense of movement: the vertical of the leading upright makes a sharp right angle with the horizontal lines of the two wings, but the tension thus created is skilfully contained within the solid armature of the sculpture as a whole.

It is intriguing to compare *Stranger III* with César's series of winged figures, of which *L'Homme de Saint-Denis (Man of Saint-Denis)* 1958 (Tate), in welded iron, is a typical example. This piece was inspired by the exploits

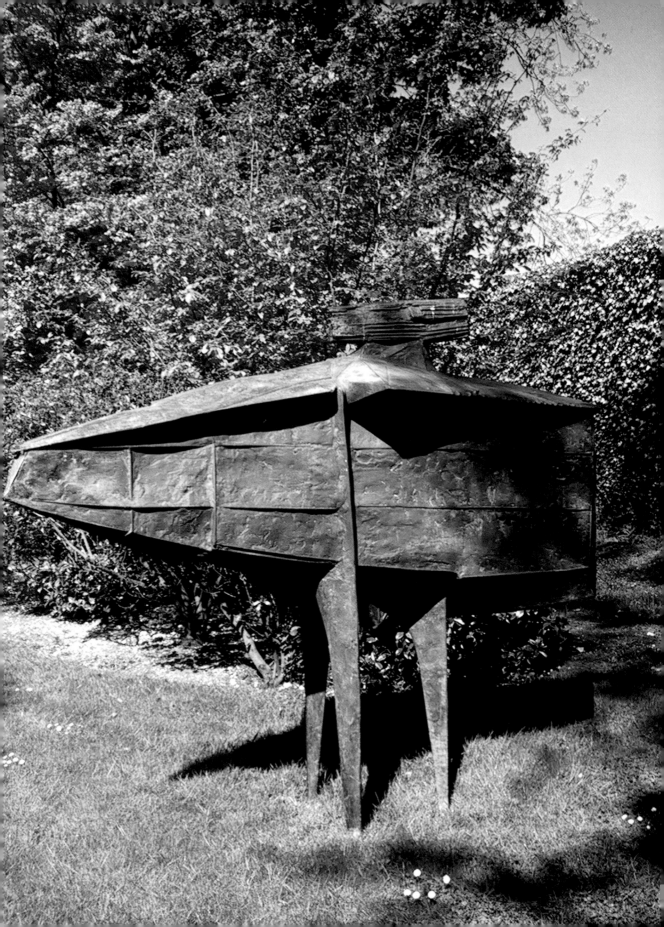

fig.20 (left)
Stranger III
1959

fig.21
Stranger II
1956

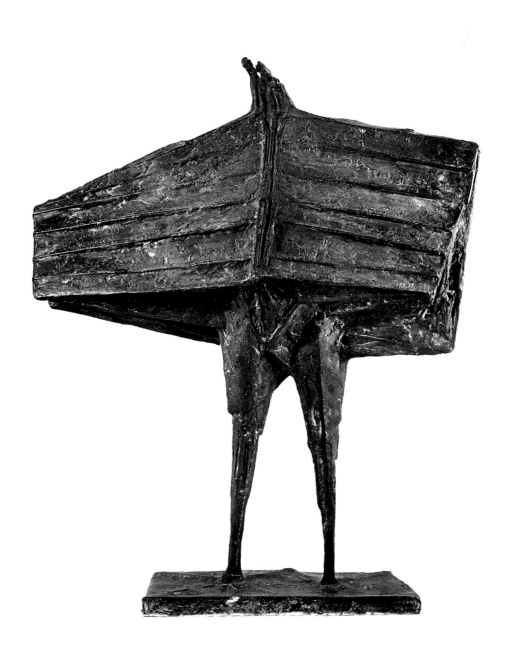

of a famous French 'bird man', Leo Valentin, who carried out a series of delayed parachute drops wearing wings made of canvas and wood, each of which were nearly six feet long.[35] Both works celebrate exploits of flight, and although Chadwick's work evolved from different beginnings, his *Stranger III* and César's *L'Homme de Saint-Denis* have spiritual and formal affinities.

Unfortunately, although approved by the Committee in July 1958, Chadwick's design was ill-received by, among others, the Guild of Air Pilots and Air Navigators, and strong opposition to it was led by Lord Brabazon of Tara, brave pioneer airman, politician and former cabinet minister, but no friend of modern art. He dubbed Chadwick's work 'a diseased haddock' and succeeded in forcing its withdrawal by the Air League in December 1958. Correspondence in *The Times* for July and December 1958 shows that some misconceptions had arisen. Chadwick refuted the suggestion that it was to be 14ft (4.3m) high (it was half that height) and cast in bronze; money, he said, was not available for a bronze cast. Subsequently, *Stranger III* was cast in an edition of four, one of which is in Spoleto, Italy; another at Colby College, Waterville, Maine; and the third was shown until recently at Goodwood.

Chadwick took the rebuff philosophically, and later reflected that his work would probably have been lost in the jumble of buildings that had accreted around the original site, citing as a cautionary tale the fate of the Alcock and Brown memorial. He also felt very ambivalent about the place of sculpture in relation to modern architecture, the enormous scale of modern high-rise buildings making the siting of sculpture as adornment to the outside of them a forlorn exercise. The place for sculpture, in his opinion, provided it had been carefully planned from the outset, was in the large circulation areas inside, where it could be properly seen in relation to its surroundings.

The *Manchester Sun* 1963–4 (fig.22), for the new Williamson Building for Life Sciences on the University of Manchester's central campus, evolved from a bronze circular sculpture of 1955, *Maquette for Apollo*. Chadwick then developed this in two further maquettes of 1963, before arriving at a definitive version made in fibreglass (with additional casts in aluminium and bronze), the material used for the 16ft (4.9m)-diameter sculpture attached high up the brick front façade of the Williamson Building. Fibreglass was chosen for its lightness and durability – bronze would have been too heavy to support safely – and the sculpture is covered in gold leaf. While it consists of an abstract pattern of interlocking circular shapes in high relief, it can also be read either as an organic, protozoon symbol appropriate to its context, or simply as suns within a sun. It is similar to some of Victor Pasmore's black and red abstract paintings of the same period.

fig.22
Manchester Sun
1963–4

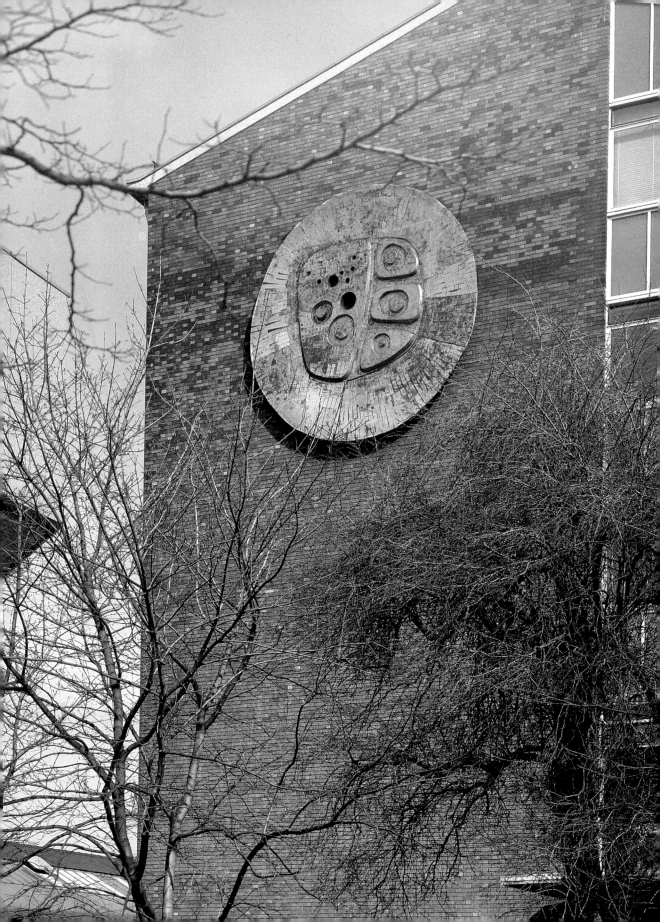

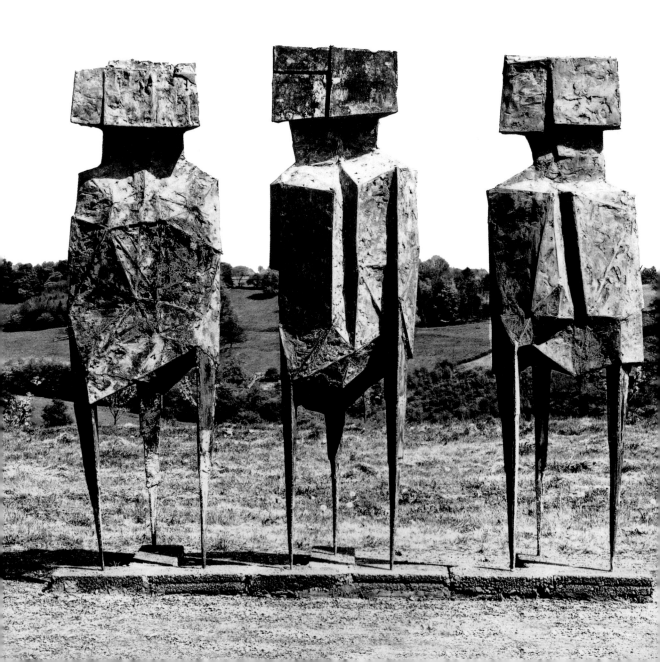

The *Manchester Sun* is happily still *in situ*, but Chadwick apparently experienced some difficulties with the commission, which came through the architect Harry M. Fairhurst, and was financed by the Carborundum Company's Sculpture Major and Minor awards scheme. First, something flat was needed, and Chadwick had not worked in low relief before; and second, he thought the Williamson Building was to be used for atomic research: 'it was at the time, but as soon as I had made the sculpture it became not that. I did something which I thought might represent atomic energy – I did a sort of sun.'[36] Harry Fairhurst's recollection of the matter differs slightly:

> The Williamson Building housed Mathematics temporarily but was always intended for Life Sciences starting with Geology (fossilized life) and the other biological sciences followed. This is why Chadwick chose the Sun as the subject, without which the Earth would not be what it is![37]

Chadwick described how the piece was made: 'We made it on the floor, in clay, and I covered the clay in fibre glass … so that I had the negative form of it in fibre glass, that's how I made it.'[38] He disliked fibreglass as a medium, describing it as 'horrible stuff', and never used it again. The architect had asked for it to be covered in gold leaf, and although the commission was successful, Chadwick expressed himself dissatisfied: 'Well, the last time I saw it, it was all right, really, but nothing on a building satisfies me, I don't like things stuck on a building.'[39] Similar sentiments had been expressed by Henry Moore.[40]

The Watchers 1960 (fig.23) began a new phase in the sculptor's repertoire: whereas previously he had confined himself to single figures or couples, he now combined groups of three, even on rare occasions four, five or more figures, in the 1960s and early 1970s. But three remained a favourite combination – 'I find three works well,' he remarked – and a trio enabled him to create an interesting rhythmic pattern. His work has a new sense of weight and solidity, and he further developed formal characteristics found in the earlier *Stranger* sculptures. Now there is a clumsiness of construction, the heads are no longer vestigial spikes, but, as foreshadowed by *Stranger III*, they have become heavy, block-like features, their rough surfaces split by vertical and horizontal fault-lines. They appear to be clad in weighty, constrictive clothing, marked, in some cases, by deep indentations or folds. They teeter incongruously on spindly tripod legs, and they appear battered and weathered. There is clearly an echo of the rude vigour of the Easter Island figures he so greatly admired; certainly there is a brutal directness, such as one often finds in West African carving, a quality that was much emulated by Picasso and Matisse in the early years of the twentieth century.

fig.23
The Watchers
1960

Chadwick said of *The Watchers*:

It's a way of saying the same thing as the Easter Island figures … but it's nothing to do with them physically, it's just the same message. These curious figures … I've made more abstract than the Easter Island ones, but they're looking, apparently, into space … But that's the idea. They're not, in any way, representative of anything. They're just shapes … You see, the Easter Island things, for me, have this great intensity of message, as it were, and I wanted to do the same thing![41]

Questioned about his use of three figures, he explained:

You see, I can see one figure is all right, I understand one figure. Two figures, yes, you can get a balance. Three is … the intensity. But four would be hopeless, you see, because you couldn't balance four, you're always going to get two and two … You see the *Elektras* [pl.5], which are three, the middle one started as part of a pair, and then that didn't work, I didn't like it at all, it didn't work at all, because it doesn't really go with anything else that I could do at the time, so that I had to make it into three, and that was all right, into a group.[42]

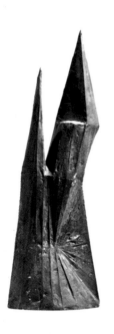

Although Chadwick always disclaimed conveying any specific meaning or message in works like *The Watchers*, preferring to stress their anonymity, he must nevertheless have been aware that the physical presence of these brooding figures would evoke a response in the spectator. They do, after all, appear to be observing us, their sightless gaze may be indifferent or hostile, but, inescapably, we feel they are surveying us. Similarly, in the later large figure groups, whether seated or reclining, their eye-level appears to engage with our own, establishing a rapport between the two.

In June 1962 Chadwick was invited by the Italsider Steelworks, Genoa, to produce a large sculpture for an open-air sculpture project run in conjunction with the Festival dei Due Monde at Spoleto. David Smith and Alexander Calder were the other distinguished foreign sculptors to take part: Chadwick worked in the repair shop at the Cornegliano site, Smith at Voltri, and Calder at the Savona branch of Italsider S.p.A. Chadwick's contribution was two enormous steel box structures, *Two Winged Figures* 1962 (fig.25), each of which measures over 9ft 6in (2.9m) high by 18ft (5.5m) wide overall. They are the most 'abstract' of all his large-scale sculptures, and he used the steel plate made at Cornegliano. Years later, he recalled how he decided to continue the winged figures theme, but this time in steel: 'I got the big sheets, you see, and I drew the outline in chalk on the sheet, and they cut it out for me, and they made these columns to support it.'[43] He was greatly impressed by the skilled craftsmanship of the Italian steelworkers. Chadwick also had one wing painted green and the other

fig.24 (opposite)
Tower of Babel
1964

fig.25
Two Winged Figures
1962

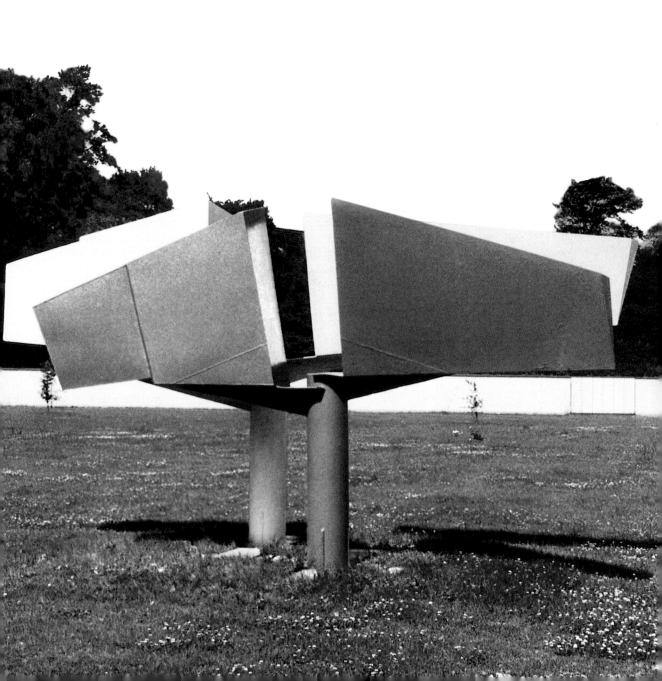

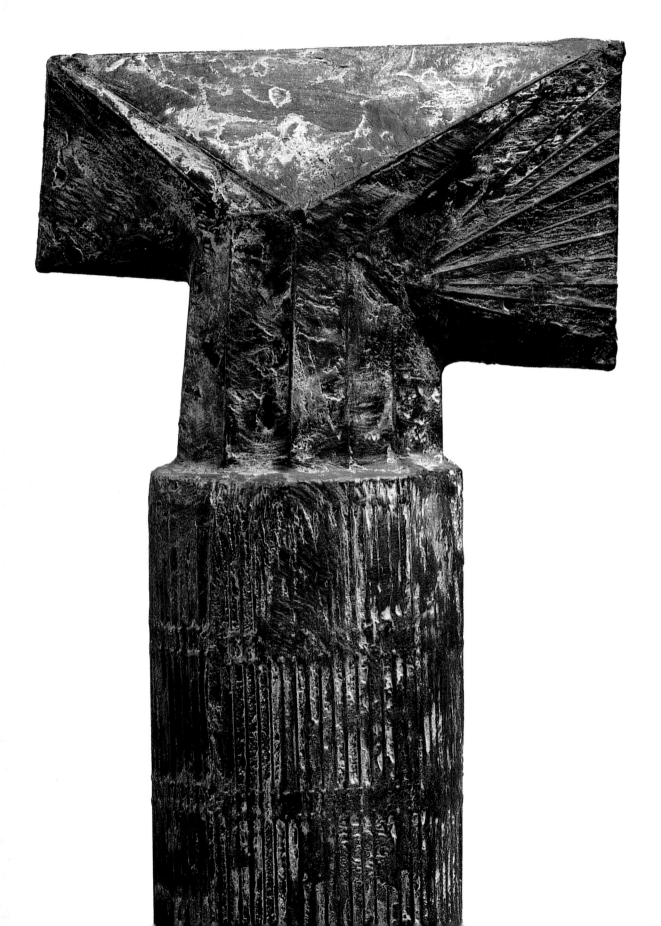

white, a reversion to an earlier practice that he had abandoned. He believed that his use of steel forms of this kind preceded David Smith's *Cubis* work, but he was equally impressed by Smith's ideas, getting to know him quite well and later stayed with him at Bolton Landing, New York. He also accepted Calder's invitation to see him at Roxburn, Connecticut, having earlier (1951) been rebuffed by him, saying then that he did not want to meet someone he regarded as an 'imitator'. Calder later made ample amends.

There seems to be some substance to Chadwick's claim that his work at Italsider may have influenced Smith's *Cubi* series of 1963–5. Smith's earlier stainless steel assemblages had consisted of thin, geometric discs and rectangles welded together to suggest a human figure; post-Voltri, Smith used box-like polished steel rectangles in his assemblages. The recollection of Smith's work, however, may have prompted Chadwick to experiment with stainless steel some twenty-five years later. The British sculptors Anthony Caro (b.1924) and Brian Wall (b.1931) had been working in steel since the late 1950s and early 1960s.

Although *Two Winged Figures* was a unique piece, Chadwick's experience of working in steel was to lie dormant, until in 1988 he began using this medium again. Meanwhile, he had begun to pursue a more light-hearted vein. Marooned by heavy snowdrifts at Lypiatt in January 1963, he looked around the old engine house where he had collected and stored old farm machinery. A series of humorous pieces assembled from old ratchet wheels, worm gears, commutators, bits of chain harrows and so forth, was the result. They often bore jokey titles, such as *Rad Lad, Oscar*, and *Tower of Babel* (fig.24). Unlike Paolozzi, who had amalgamated similar ready-made objects into his sculptures (the *Cyclops* series of 1957, for example, fig.27) and then had them cast in bronze, Chadwick welded the scrap together so as to allow the parts to retain their own identity while yet transformed into semi-figurative objects by their juxtaposition in each sculpture. There is, too, more than a passing reference to the irreverent Pop art culture of the early 1960s. Chadwick regarded them as experimental work, and they were rarely sold.

Side by side with this playful, small-scale work, and the *Watchers*, Chadwick explored a more abstract road, inspired perhaps by his work at Italsider. He began producing pyramidal shapes such as had been used in *The Unknown Political Prisoner* maquette, but now developed either as severely geometrical forms, or as totems, like *Proctor* 1964 (fig.26), or *Conjunction X* 1964 (fig.28), where the reference to conjoined torsos and legs is both specific and yet abstracted. The pyramids, often boldly multicoloured, were experimental works which culminated in an environmental display for the Milan Esposizione Triennale in 1968, but which Chadwick did not feel able to develop further.

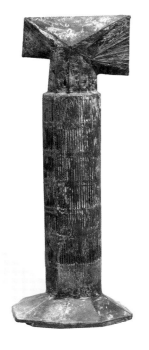

fig.26
Proctor
1964

fig.27
Eduardo Paolozzi
Cyclops
1957

fig.28 (opposite)
Conjunction X
1964

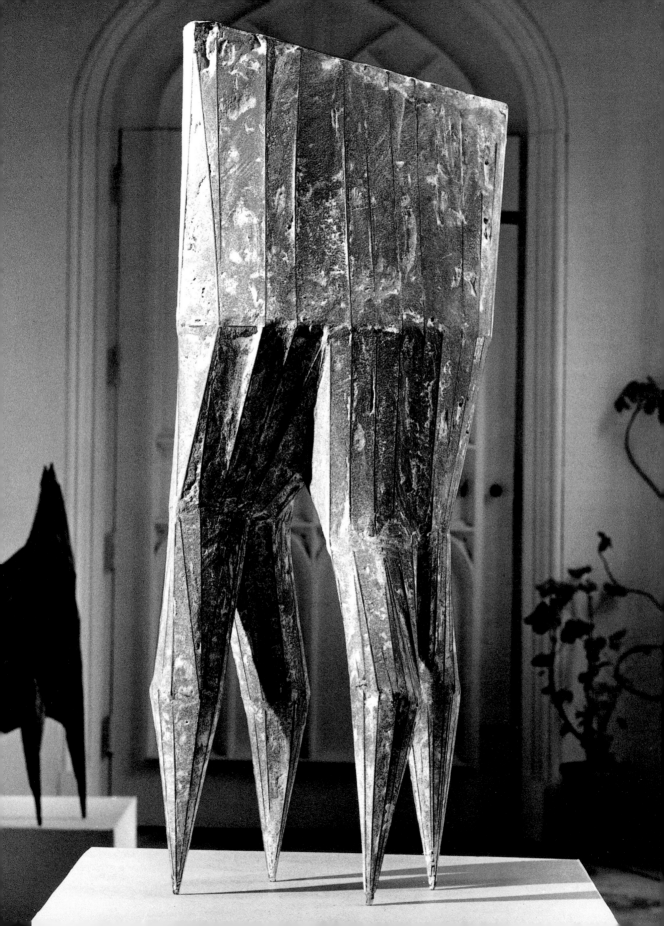

During the 1960s Chadwick did elaborate and refine his *Watchers* and *Elektra* series, and in 1969 produced *Three Elektras* (pl.5). We have already mentioned his predilection for groups of three figures, and here the three 'Shining Ones' (which is one of the meanings of the Greek 'ηλεκτρα) present a subtly choreographed group of female figures. Their individual poses complement each other: the figure on the left tilts her hips inwards, the figure on the far right tilts hers a little more emphatically inwards and at a different angle, while the central figure, broader across the hips and plumper, stands four-square and acts as anchor. Chadwick meant them to be set close to each other, but not touching. In one version of the group, both face and part of the torso of each figure is highly polished; in another, only the faces are polished; and in a third, the sculptures are left black. The polishing was done in 1970 as an experiment, and is a purer method of introducing colour into sculpture: by doing this, Chadwick exploits the intrinsic qualities of the bronze medium; nothing has to be added.

By now, too, Chadwick had evolved a new formal symbol for the female and male head: his female figures now had diamond or triangular-shaped heads, his males square or rectangular heads. There is also a greater refinement of modelling, especially on the breasts and abdomen of his females, for although cast in a hard, durable material, there is a softness, a sensuous svelteness on the polished areas that was new to his work. This was quite deliberate: 'The "Elektras", shall we say, are more refined. "The Watchers" are very rough, crude things, on purpose, because they're representing something primitive, I suppose, to me.'[44] At over 7ft (2.3m) high, the *Elektras* are also more monumental, standing on sturdily constructed box-section tripods instead of the attenuated stalks of earlier work, and are slightly rougher in texture. Again, Chadwick was emphatic that the title 'Elektra' was purely descriptive, and is neither a reference to the *Oresteia* of Aeschylus nor to Sophocles' *Elektra*, where she is a central, avenging figure; his approach is thus diametrically opposite to that of Francis Bacon's, whose *Triptych inspired by the 'Oresteia' of Aeschylus* 1981 contains imagery and symbolism directly related to the eponymous Greek tragedy. Nor does Chadwick's work carry a fierce expressionist charge; there is sometimes ambiguity, but never the disquieting disjunctions of overt surrealism. In answer to my comment that the *Elektras* seemed to exude a feeling of menace, he said that he had not intended this.

Chadwick was to exploit the *Elektra* theme in a series of single figure sculptures, some lying, some standing or sitting, and made in various sizes. He could always make a figure larger, working from a maquette, but it would never be a literal transcription on a larger scale, for he always felt the urge to introduce a new element, a modification to the pose, say, or a different treatment of the surface textures. He had always felt that in the process of enlarging from a small sculpture much of the spontaneity was lost: 'You've already done it! You must improvise as you go along … working directly is best, even a slight mistake is not a mistake for it hasn't been corrected yet.'

Figure Sculpture of the 1970s

fig.29
Diamond
1970

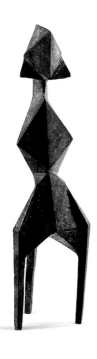

Diamond 1970 (fig.29) is a further development of the *Elektra* figure, but here Chadwick has simplified the female body into a series of interlocking diamond shapes, a variation, in fact, on the tetrahedrons that make up the structure of his early *Dancing Figures*. It is a logical progression, and he was to explore the theme by using shiny surfaces in some of the versions, but always incorporating a new pose or, to use his word, 'attitude'. Thus, in *Sitting Figure* 1970 (fig.30), he produced a highly polished reclining figure, divided into three constituent diamond forms, with a rectangular, sloping-sided cube for the chest and abdomen; all three parts are anchored to a polished base. An even more severely geometrical version was made in gold in 1971, and shown at the Worshipful Company of Goldsmiths, London, in 1974.[45] These two sculptures of a sitting figure are the only ones known to me where Chadwick has split the body into three separate sections. Henry Moore's series of *Two-Piece Reclining Figures*, dating from the late 1950s, and many subsequent two- and three-piece reclining figures, may have been remembered by Chadwick, but he seems to have arrived at his own solution as part of a logical sequence, and it may be significant that he did not repeat the experiment. The bronze *Diamond* sculpture was later used as a basis for two of Chadwick's early steel sculptures, *Palm Beach Blue* (fig.42) and *Hello Paris* (fig.31), both of 1988.

A group of *Five Sitting Figures* 1975 (fig.32) neatly encapsulates the sculpture of the 1970s, where Chadwick has reverted to earlier themes and then delights us by presenting new aspects of them. The figures sit or recline, they are clad or naked, but they are always lively and suggestive of fresh directions that Chadwick might follow.

By now Chadwick had secured worldwide recognition, had been appointed CBE in the New Year Honours List of 1964, and had participated in many group and one-man exhibitions across the globe, particularly in Europe, North America and Japan. He now had an informal arrangement with Marlborough Fine Art, for after an initial two-year contract signed in 1960 he had preferred to remain independent, although there was always an understanding that the Marlborough would exhibit his work on a regular basis. But the task of administering the business side of his affairs was not easy for him, a fact he had been aware of many years earlier when

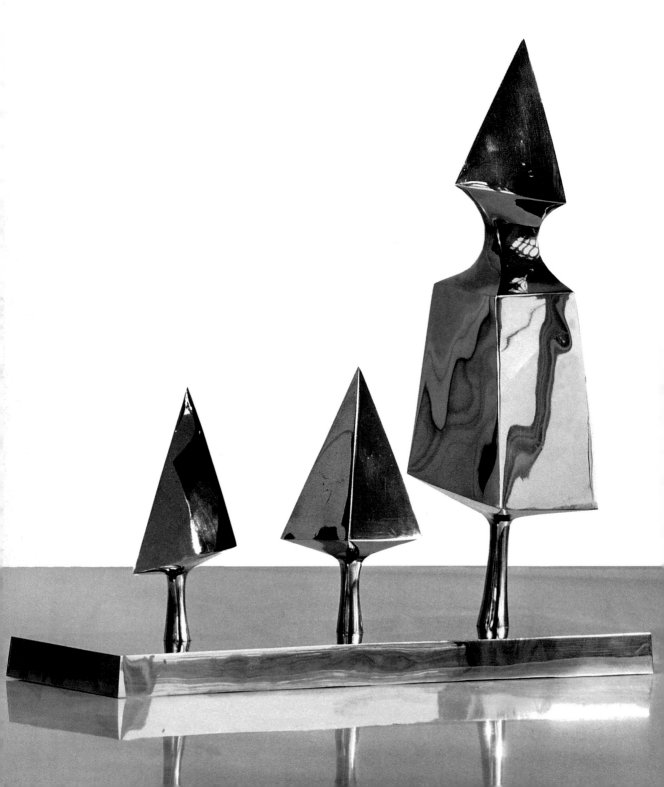

fig.30
Sitting Figure
1970

fig.31 (opposite)
Hello Paris
(at Chalfont Studio)
1988

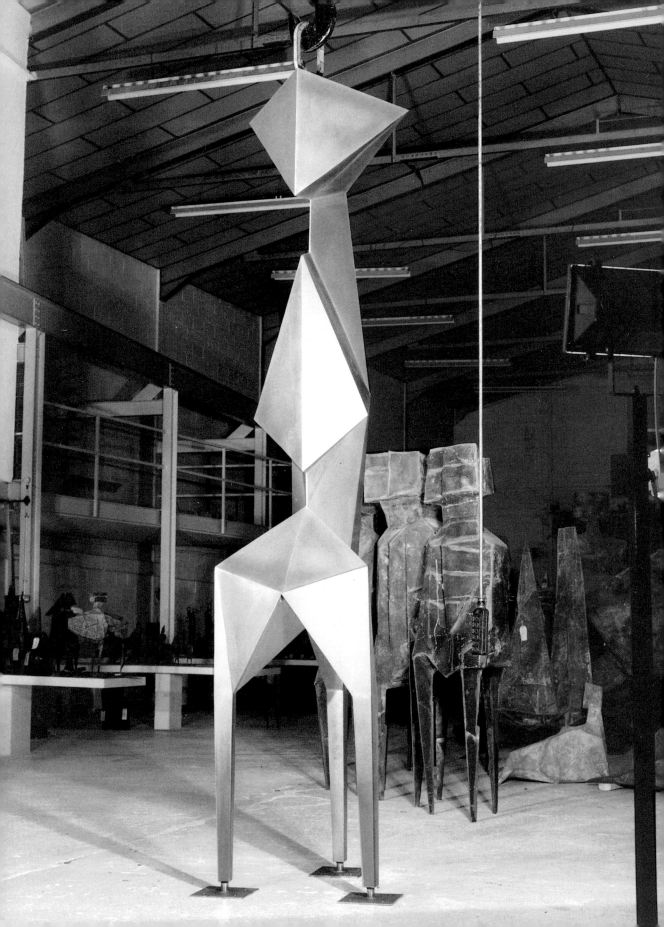

contemplating a career as an architect. The cost of casting had been borne by his dealer but set against future sales, and in 1964 Chadwick found himself heavily in debt. His personal affairs were also going badly. In 1959 he had married Frances Mary Jamieson, after his first wife left him and from whom he was divorced, and his two daughters, Sarah and Sophie, were born. Then in 1964 Frances left him and died in tragic circumstances. It was a traumatic period in his life, but, as he later recalled, he maintained an outwardly impassive demeanour: the traditional British 'stiff upper lip'. He had always felt able to keep control of his deeper emotions. He later married Eva Yvonne Reiner, who had been born in Paris of Hungarian parents. They had a son, Daniel Sebastian, who, after abandoning a course in engineering, now makes mobiles and sculptures.

Chadwick appears to have continued to work with undiminished power, and when Eva Chadwick began to take care of the administration of Lynn's affairs, always consulting him about important matters, he was freed to do what he did best: sculpture.[46] So successful were they as a

fig.32
Five Sitting Figures
1975

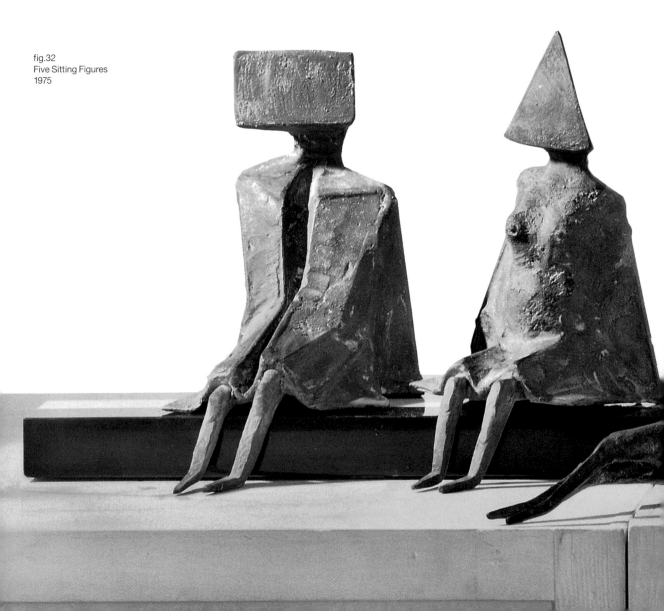

husband and wife team that by 1971 they were able to open a foundry at Lypiatt Park and become financially independent of dealers, though collaborating with them for exhibitions in commercial galleries. That same year they met Rungwe Kingdon, who had established his own foundry and was eventually to become Chadwick's sole authorised founder in 1989. There was also a practical reason for having their own foundry, since in that way Chadwick could exercise close quality control over the castings. He told me in 1987 of some of the crimes that the less scrupulous bronze founders committed in order to save time or through carelessness compounded by ignorance. Legs could be cut off or put at the wrong angle, pieces broken off and not properly replaced; these were but a few of the annoyances he had had to put up with at times.

Two Reclining Figures 1972 (fig.33) stems directly from the reclining *Elektra* figures of 1969–70, which were, after *The Watchers* (1960), the second of Chadwick's major figure groups; large group and single-figure works henceforth dominate his output over the next twenty years or so.

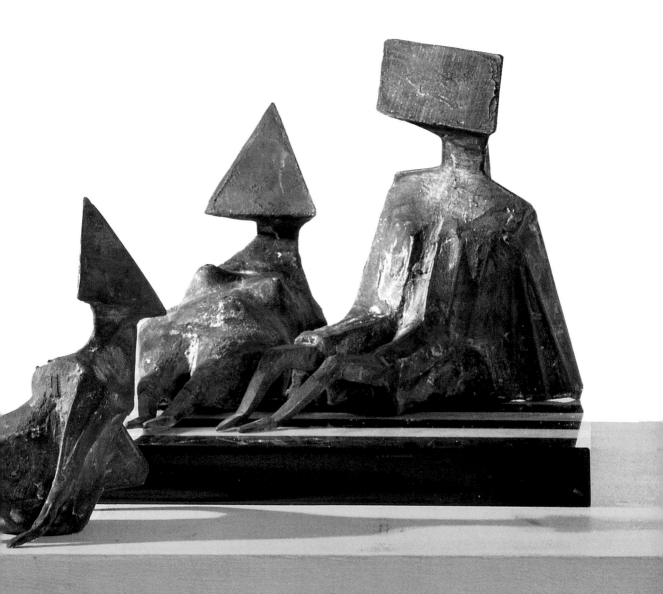

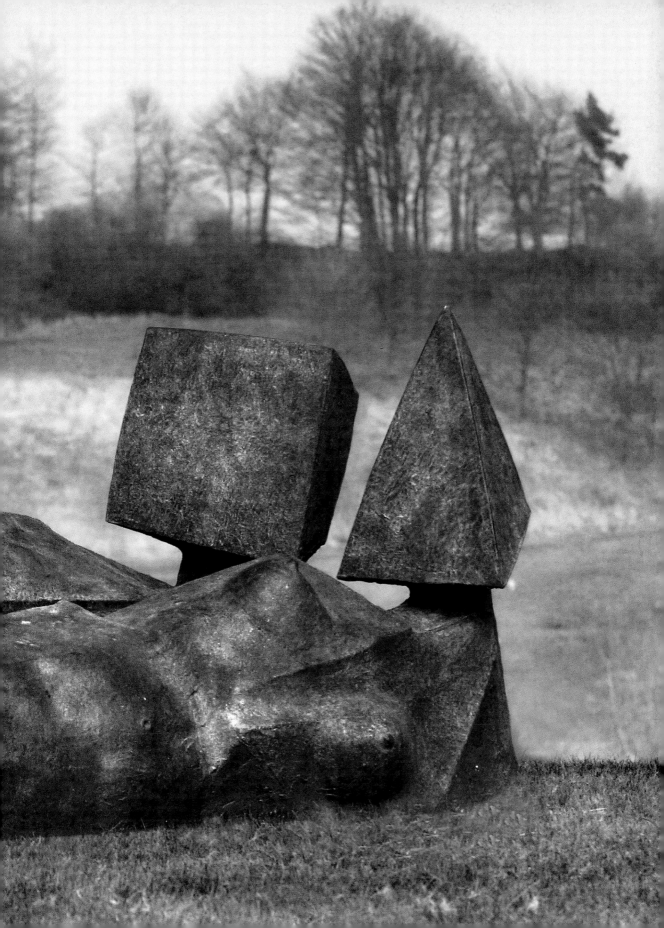

The familiar process of preliminary maquettes in which he tested out ideas was followed here, but there is a new authoritativeness, a new versatility of means at his command, that marks out his mature style. He was also consolidating, building on his earlier work certainly, but having established his formal language, as it were, he needed to refine and enrich it.

There is, too, a new tenderness in his work: in *Two Reclining Figures* a man and a woman loll contentedly side by side, as if sunbathing on the seashore or replete after a picnic on the grass. The woman's breasts are delicately modelled, the nipples naturalistically described. The male figure is clad and chunkily modelled, his sharply angular shape contrasted with the softer contours of the woman. Yet both have anonymous heads: the familiar pyramid and rectangular notation of female and male. In this way Chadwick seeks to generalise, to make an archetypal group.

Cloaked Figure IX 1978 (fig.34) picks up on an idea that Chadwick had begun to explore in the 1960s in his *Winged Figures* series and, indeed, that first appears in embryo in *Teddy Boy and Girl* (fig.17) and *The Watchers* (fig.23) but which he now accentuates. The heavily draped female figure sweeps along, her cloak trailing on the ground, and by such a device Chadwick conceals her legs (although we catch a glimpse of her right leg) but at the same time provides a solid support for his sculpture. He builds up her figure in a sequence of broadly triangular-shaped facets, but exploits the soft outlines and sensitive modelling made possible by the use of bronze. He was early in his career fascinated by the finish and patination of Marino Marini's bronze sculptures, which he had seen at the Hanover Gallery, London, in the 1950s, but in *Cloaked Figure IX*, as in the *Three Elektras* (pl.5), one feels he has really mastered the technical possibilities of his medium. This tall, majestic and elegant figure glides towards us, her arms holding her cloak close to her body, yet parted sufficiently to allow her limbs to move. The folds of the cloak ripple and undulate around her, defining her shape yet simultaneously concealing it, giving her an aura of mystery, even remoteness.

fig.33 (previous page)
Two Reclining Figures
1972

fig.34
Cloaked Figure IX
1978

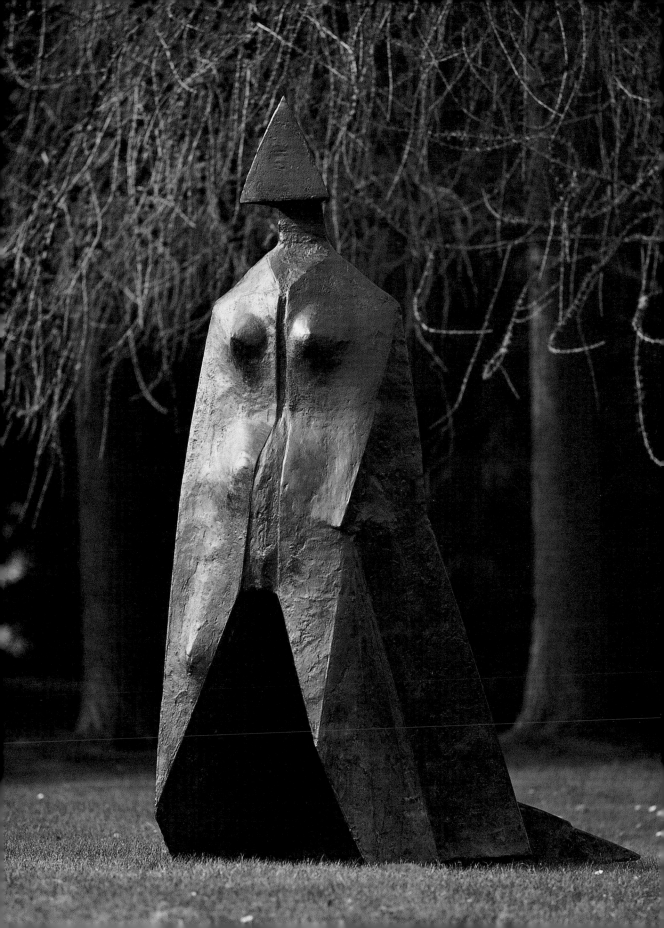

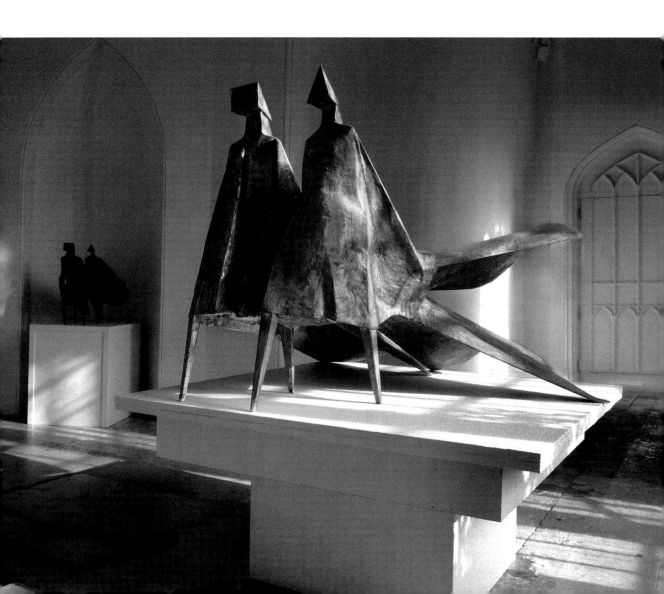

'Back to Venice' and Other Sculptures 1980–90

Walking figures, their cloaks or robes blowing out behind them, provided Chadwick with a theme capable of sustaining endless variations, of which *Maquette Jubilee II* 1983 (fig.35) is a particularly dramatic example. A larger version of the subject, *Pair of Walking Figures – Jubilee* 1977 stands nearly 8ft (2.4m) high, and there the cloaks billow out behind them to form tube-like appendages.[47] In *Maquette Jubilee II* the robes form an elaborate butterfly-wing shape behind the two figures, supporting them too, but now imbued with a baroque exuberance that transcends the merely practical. Chadwick has enjoyed creating a fantastic shape for its own sake, rather as some of his female figures carry their skirts like a fan-tailed pigeon displaying its plumage.

Chadwick returns to the theme of wind-blown drapery in a series of bronzes, of which *Maquette V High Wind* 1984 (fig.36) and *Maquette VIII High Wind* 1986 (fig.37) are two of several variations of the subject. In the first of these, a woman has her hair and skirt blown forward by a gust of wind; her face is covered and her close-fitting bodice shows off in profile her breasts in an amusing counterpoint to the forward sweep of her hair and skirt. Her legs and feet are delicately described. In the later variation, the woman's skirt loops up in front of her, free from the ground, to become a shell-like form; she tilts her body forward, throws her weight on to her left leg, as if battling to maintain her balance. The overall shape of the sculpture can almost be read as a simplified abstraction, yet its figurative starting point is equally clearly defined. These little maquettes have great dynamic brio, but Chadwick denied having watched people in the wind: 'No, I was just looking for some reason, in order to do this idea of a skirt being rather tight round the body', and 'I like to get a bit of movement in my work.'[48]

In fact, of course, Chadwick told us only a part of the story in this comment. It seems clear to me that in seeking to solve a practical problem of supporting a figure, he allowed himself to use the hem of the skirt as a point of support in one of the sculptures, and in the other he fixed the figure to a base and cantilevered it from that base. At a more general level, however, Chadwick had relied on the many images stored in his memory of how figures appear when windswept. It is tempting to see a parallel with the bronze ballet dancers of Degas, in which he closely observed the

fig.35
Maquette Jubilee II
1983

fig.36
Maquette V High Wind
1984

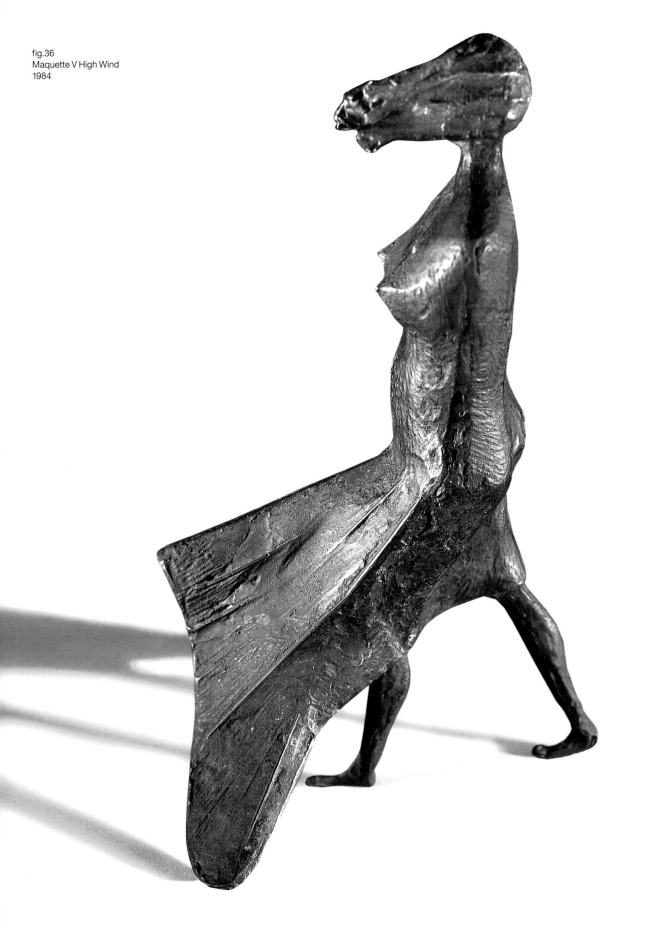

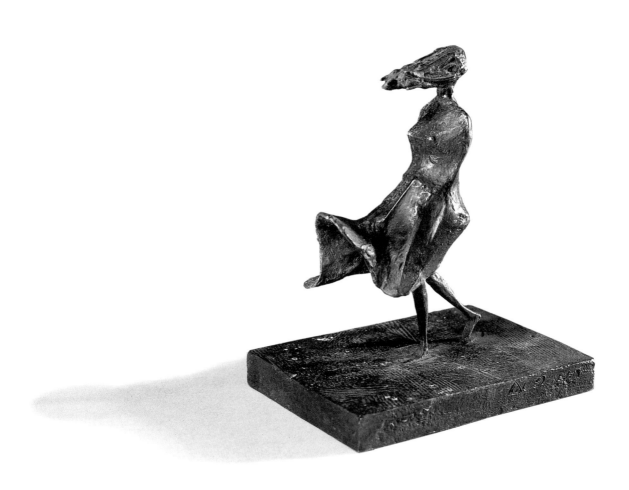

fig.37
Maquette VIII High Wind
1986

fig.38
Amenhotep III
1400 BC

fig.39 (opposite)
Henry Moore
King and Queen
1952–3

various dance movements and sketched them, before translating his databank of images into sculpture. But Chadwick arrived at his solutions by a slightly different, less specific route.

In 1988 the Director of the XLIII Venice Biennale invited Chadwick to contribute a major figure group to a special international sculpture survey, and *Back to Venice* 1988 (pl.6) was the result. I first saw the piece in February 1988, when the male figure was still at the steel armature stage, but the female figure was nearly ready for casting. What I noticed then was the very spare modelling and tremendous feeling of taut energy. On looking more closely I saw, too, that there was a great subtlety of modelling in the folds of the drapery across the back of the figure. Chadwick had dragged a French plasterer's comb through the wet Stolit, thus producing an evenly spaced sequence of ribbed horizontal volutes lying across the fall of the drapery, which he subsequently partly smoothed off in some areas. When cast in bronze later that year, this produced a beautifully rich texture that is not so obvious in some of his earlier figures, where the surfaces are blander and more matt. The female figure is clad and vestigial traces of a dress flow out from her hips and drape over her lap. The male figure, by contrast, appears to wear some kind of loose robe with square shoulder cape and lapels, that splits open down the front to form a deep fissure.

Back to Venice occupies as pivotal a role in Chadwick's work of the 1980s as the *Three Elektras* fulfils for the 1960s. It comes as a culmination of a number of earlier seated couples of the 1980s, and is one of the most magisterial. As in the *Elektras*, the poses of the individual figures complement each other and have been carefully considered. The two figures appear to lean ever so slightly towards each other. Chadwick differentiates the genders with uncompromising directness. The woman is more lightly built, her shoulders slope at a softer angle; the man's square, muscular shoulders, heavier build and barrel chest and waist display a hard-edged virility. The two figures have a hieratic stillness and frontality that reminds one of Egyptian monumental sculpture, but this stern, brooding quality is not disquieting, and unlike their Egyptian forebears, the group is meant to be seen in the round, from many different angles. The colossal seated statue of Amenhotep III of 1400 BC (British Museum, fig.38), for example, points up both the similarities and differences in approach. A more recent prototype, in the broadest sense of the word, is Moore's *King and Queen* of 1952–3 (fig.39), though the differences between the two works are as instructive as any superficial similarity that may exist. Moore's sculpture has a specific regal connotation; Chadwick eschews any literary or historical reference, except the jocular allusion to his 1956 success and, perhaps, as a gracious acknowledgement of the

invitation to exhibit again at the Venice Biennale. The two sculptors' approaches to the human figure are radically distinct: Moore's softly rounded forms and particularised treatment of hands and feet, the symbolic notation of eyes and noses, and the coronets, are all comparatively naturalistic in style. The figures have a weathered, 'archaeological' semblance, which is very different from Chadwick's harsher vocabulary. Instead of a simple bench, Chadwick's figures sit on a broad rectangular slab supported on a low plinth. The two sculptors use texture in dissimilar ways: Moore chases and scores his surfaces; Chadwick lets the texture of the Stolit show and tends not to polish or chase the surfaces of his bronzes; he also preferred a grey-black patination, rather than the usual bronze colour.[49] Both men, in their differing ways exploit the peculiar qualities of bronze: its hardness combined with marvellously sensuous surfaces.

High Wind II 1988 (fig.41) is, like *Back to Venice*, a definitive summation of an idea Chadwick had been experimenting with for over a decade. It stands some 6ft (1.8m) high, and is a brilliantly dynamic figure, presenting dramatic profiles from several viewpoints. In the process of enlargement the woman has become a leaner, sparer figure; the softer outline of her breasts and buttocks is counterbalanced by the angular bone structure of her elegant neck and shoulders; the legs are an interesting hybrid between the naturalistic treatment of those in the maquettes and the necessarily more robust square-sectioned limbs needed to support a heavy, life-size sculpture. The blown skirt, too, has a sharper profile, and is again deployed as a support for the whole figure. Chadwick's use of a plasterer's comb, first noted in *Back to Venice*, appears again on the thighs and back in the vertical striations that suggest the fabric texture of the dress. Chadwick made two more 6ft variations of *High Wind*, in 1990 and 1995, and used the theme in a more intricate group of figures ascending and descending stairs (fig.45 and pl.7).

As an envoi to this phase of Chadwick's work comes *Pharaoh's Dream* 1989 (fig.40), a small polished bronze *jeu d'esprit* of great wit and charm. The symbolism of a pyramid and a woman's breast hardly requires explanation, but the concept itself is perhaps the only time Chadwick used the surrealist technique of an unusual conjunction of familiar objects. It is a kindred spirit to René Magritte's light-hearted spoofs.

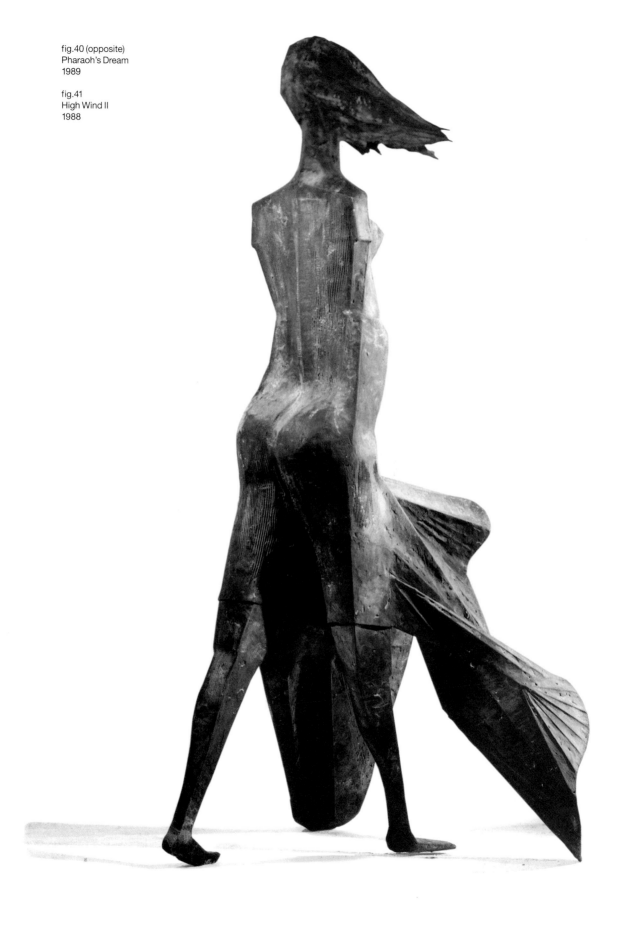

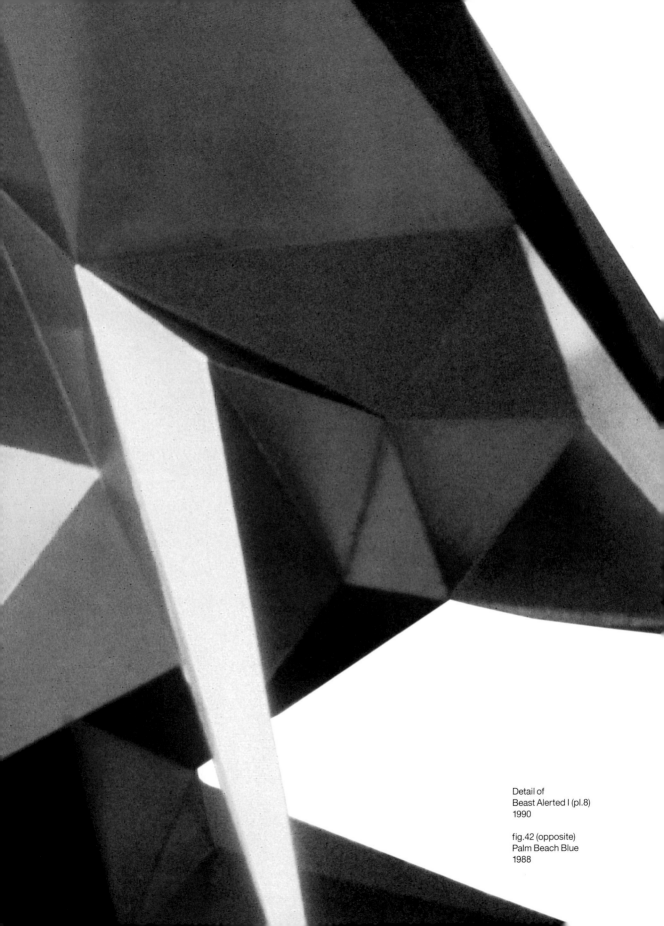

Detail of
Beast Alerted I (pl.8)
1990

fig.42 (opposite)
Palm Beach Blue
1988

The Steel Sculptures
and Late Works

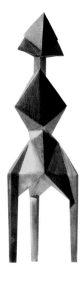

In 1988 Chadwick embarked on a radically new development: he began to use sheet stainless steel, and recreated some of his earlier sculptures in this new medium. To be able to do this he employed a specialist technical assistant, trained in Birmingham, sufficiently skilled to cut the ⅛in (0.4cm)-thick sheet to the desired shapes and weld it up into a sculpture, under Chadwick's supervision. When sheet metal is cut into sections by sawing or oxy-acetylene cutting, warping can occur and because stainless steel is harder than mild steel, a guillotine must be used so as to produce a 'straight flat cut'.[50]

The first of the maquettes to be transformed into a stainless steel sculpture was *Diamond* 1970 (fig.29), renamed *Palm Beach Blue* 1988 (fig.42) and made over 11ft (3.4m) high, which had been commissioned by Palm Beach Airport, Florida; this was followed by *Diamond Trigon II* 1970, which became *Hello Paris* 1988 (fig.31), over 12ft (3.7m) high, commissioned by Le Ponant, a new building complex on the site of the old Citroën factory beside the Seine in Paris. Chadwick used a metallic blue for some of the triangles that form part of the front of the figures, thus giving the sculptures additional brilliance. The first completely reworked design in stainless steel is *Inox* 1989 (fig.43) which, although loosely based on the little *Rad Lad* maquettes of 1961, can be regarded as an autonomous creation. The hard, precise profiles and brilliant reflective surface of stainless steel are qualities that greatly attracted Chadwick, and he fully exploited their potential. It is almost as if his old predilection for precision architectural drawing had reasserted itself some forty years after he had left Rodney Thomas's office, where he had prepared 'tolerance' drawings for prefabricated building units as part of his daily work for the Arcon Group immediately post-war.[51] This strange Alien creature, *Inox*, has a topical Space-Age appearance and is a distant cousin of *The Watchers*, but where there was once a craggy roughness of outline and texture, a shambling hulk has now been replaced by a high-technology robot-like figure that one feels could easily have been produced by a computer. The huge welded-iron *Two Winged Figures* of 1962 (fig.25), made for Italsider, has spawned this creature.

I have already suggested that David Smith's steel sculptures may have

spurred Chadwick to experiment further with this medium, more than twenty years after his Italsider project. It is indicative of Chadwick's willingness to explore new techniques and materials, even late in his career, that he switched from the patently hand-worked earlier sculptures to a semi-industrialised process, at several removes from the studio. The demands of the medium, stainless steel, also impose themselves on the way in which subject-matter is interpreted. We have moved away from the tender observation of the human figure to a harsher, mechanistic world, populated by fierce beasts and faceless automata. Why this change? In truth, the beasts and anonymous but watchful figures have been there all the time in Chadwick's work, but the challenge presented by the implacable medium of stainless steel awakened in him a violent aggressiveness of expression.

Chadwick has explained the method by which the stainless steel sculptures were made:

> I don't use the sheet stainless steel … because it requires a special type of welding and you have to be an expert, and I wasn't going to dabble about in something I couldn't really do. So what I did was I made a diagram model in the form of a wire frame and someone else measured all the dimensions of all the various triangles and heights, and everything like that, from the model, and enlarged it, and it worked very well.[52]

The fact that an assistant actually carried out the enlarging process did not conflict with Chadwick's own reluctance to make a straightforward enlargement, for he felt that he could never do this without the sculpture losing vitality, whereas transmuting the design into another medium does not seem to have involved any such loss. And Chadwick had always wanted his assistants to be technicians, not sculptors *manqués*. An exception to this rule was John Hoskin, who briefly assisted him in the early 1950s.

In conversation, Chadwick expressed his delight in the technical possibilities afforded by stainless steel, for no matter how dull the day, some facet of the steel sculpture will catch and reflect the light. The surface has, in fact, been brushed so as to accentuate the play of light.

Among the first of his earlier works to be transformed into stainless steel were the *Crouching Beast I* 1990 (fig.44) and *Beast Alerted I* 1990 (pl.8), which seem to have become even more ferocious and menacing in this medium. The early *Beasts* are usually shown crouching or poised to leap at an unseen attacker. They are all generalised creatures: only one could be read as bovine, the rest might be guard dogs or lions and tigers; some are, in fact, called lions, but as in his figure pieces, Chadwick

fig.43
Inox
1989

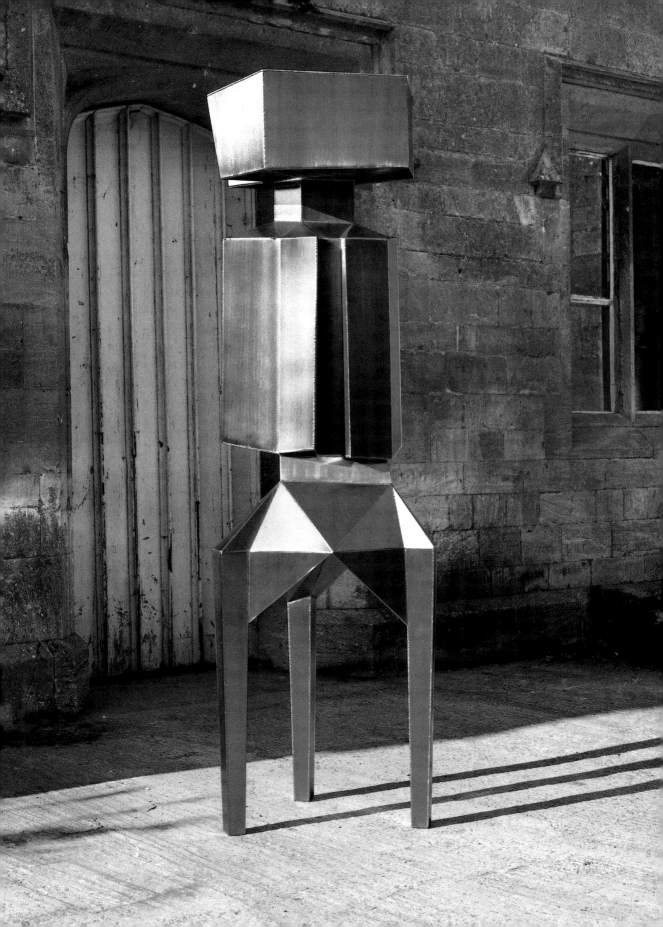

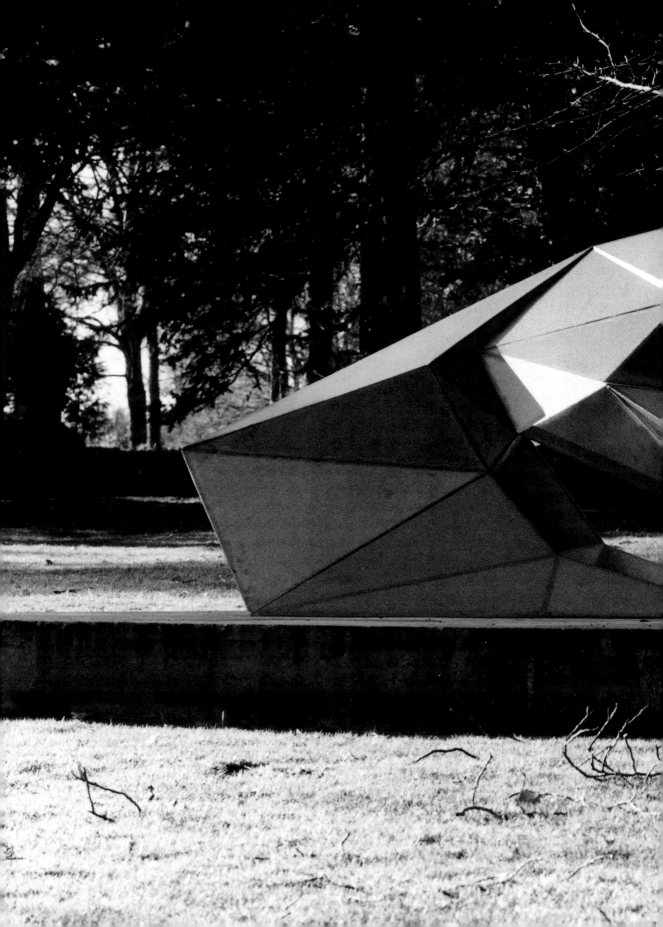

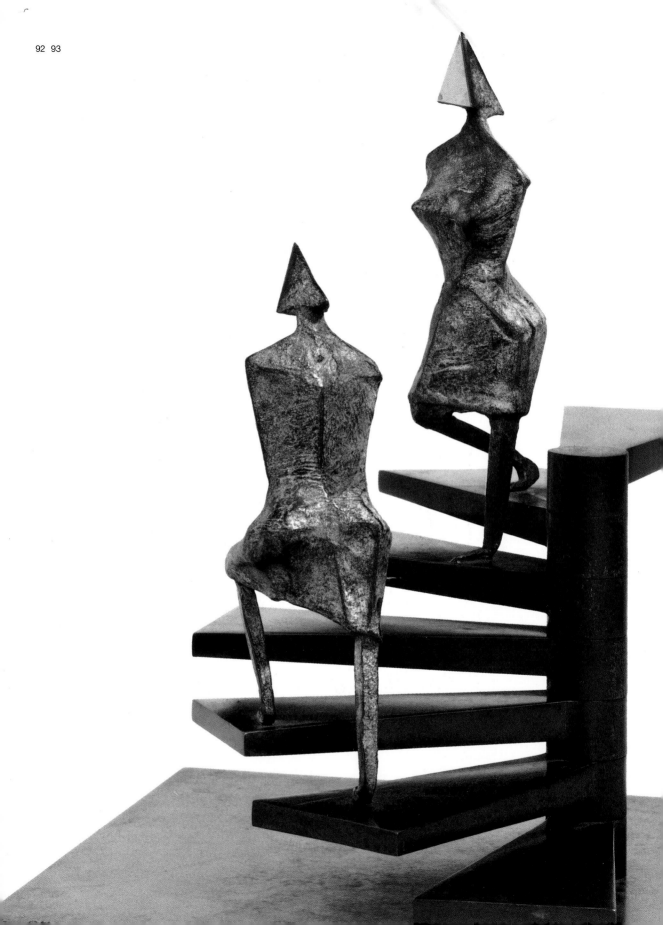

preferred usually to concentrate on the generic rather than the specific. All are shown tensed for action, with muscles taut and mouths agape, fangs metaphorically bared. In *Beast Alerted I* the body, head and tail form a dynamic zig zag, as the beast rises on its forelegs and twists its head to face the enemy, its tail set at a counterbalancing angle. Only one other sculpture, *Beast XVIII* 1959, has the same pose, but in a less dramatic form. We do not feel these can possibly be domestic beasts, especially when they stand seven or eight feet high: no, they are feral and hostile. *Beast Alerted I* has also been cast in bronze, combining the angularity of the steel version with the softer, more sensuous qualities of bronze. Chadwick saw no contradiction in this; for as we have already noted, the old 'truth to materials' ethos of the 1930s had long since been abandoned, even by those who had once espoused it as an article of faith.

Is the potential violence exhibited by these beasts, heightened as it is by the harsh medium of which they are made, symptomatic of some internal necessity, to use Kandinsky's phrase? Chadwick had always been willing to discuss his work in formal terms, and refused to assign meanings to individual sculptures. Some, like *Teddy Boy and Girl* 1955 (fig.17), have a specific allusion, others have purely descriptive titles, and some, like *The Watchers* 1960 (fig.23), have teasingly ambiguous titles, but almost all sprang from Chadwick's powers of observation of natural forms. I think he had always been acutely responsive to the natural world, but there is an inherent paradox in his use of a most inflexible material such as iron or steel, to produce delicate metal membranes (as in *Dragonfly*, fig.4) or, by switching to steel, creating sharply defined clangorous forms as in *Beast Alerted I* 1990 (pl.8). It is precisely this need to exploit the limitations of a medium, as he explained in 1955, that fascinated him from the time he began to create sculpture.

Much gentler in mood, though still exploring the theme of movement, are the series of sculptures in which the female figures walk up and down stairs, as in *Stairs* 1991 (pl.7) and *High Wind on Stairs III* 1994 (fig.46). Asked why he chose this subject, Chadwick answered:

> Oh, that was just a sort of idea of the contrast. I'm contrasting various shapes, so I thought I'd contrast the movement of legs going up and down stairs, so you get the legs, the knees bending one way, then the other way.[53]

Pressed further as to how the idea came to him:

> I was really thinking, 'How else can I do these curious figures of mine? What shall I do with them? What can they be doing?' Because they'd been sitting and standing and all that. 'What shall we do now? Let's have them going up stairs.'[54]

He also explained that the steps should be as transparent as possible, because he did not wish them to become objects in their own right, as that 'would confuse with the sculpture'. He may also have remembered that Moore had seated a female figure on some solid steps in 1956, but Chadwick's solution is very different from Moore's.

Chadwick was asked why he had shown his women without arms, and replied:

> No, I never knew what to do with the arms ... they're a bit awkward. In fact I always thought the Venus de Milo is much better off, *because* she's got no arms, that's how I looked at it ... I'd already worked out a technique for doing something that did not need arms, and a lot of people don't notice that there aren't any arms, that's what I can't understand ... I suppose it's because a certain amount of their structure does relate back to the bird forms, and we accept that birds have legs and no arms.[55]

The legs of his female figures in both these and the earlier *High Wind* sculptures are quite naturalistically modelled, but the faces remain ciphers. The two women in *Stairs* pass one another, oblivious, it would seem, to each other's presence. They are self-contained within their own worlds. *High Wind on Stairs III* is, of course, a development of his earlier windblown lass, but now she ascends a flight of steps, hair and skirt billowing in front of her, and again, the skirt helps to anchor her weight to an upper tread of the stairs. In other variations on the theme, Chadwick makes his two women pass each other on a circular stair, thus introducing a helical twist to the vertical ascent/descent movement as in *Spiral II* 1991 (fig.45). We are back, in a sense, to the suspended elements of Chadwick's early mobiles, which revolve and float in space. Here, now, the figures, while not floating, still revolve in space.

By 1996, Chadwick's sight had begun to fail, making it difficult for him to work; he also experienced problems with his legs and so retirement became inevitable. His working career as a sculptor had spanned over fifty years, and continued long after many people would have contemplated a quiet life of ease. But Chadwick was a compulsive, almost obsessive worker, and sculpture makes huge demands on a human physique. Although he never attempted carving, the welding process he used meant standing often for hours at a time until the armature had been completed to his satisfaction. Then came the Stolit, followed by working and shaping this after it had hardened.

Chadwick had never taught, even in his early days when a little extra income from it might have been welcome. He was asked to teach at St Martin's School of Art, but had to refuse because of other commitments at the time (probably the mid-1950s). Although he had no objections to trying

fig.46
High Wind on Stairs III
1994

his hand at it, he felt that one had to have a special gift for it. He thought he was probably too egocentric to be able to create enthusiasm in others, which is what he considered a good teacher should strive to achieve. In 1962 he was invited to be Artist in Residence for a term at the Ontario College of Art, Toronto, where he was given a studio to work in:

> and I produced a lot of work ... there was the assumption that I would mix with the students, and talk about their work, or something ... I said I would be very glad to meet them and talk. They were invited to come and see me any time they liked. That's how I did it.[56]

Clearly, Chadwick did not feel this kind of activity was really his *métier*, and he never repeated the exercise. He felt that there was no way of ascertaining what sort of reaction he had sparked off, if any!

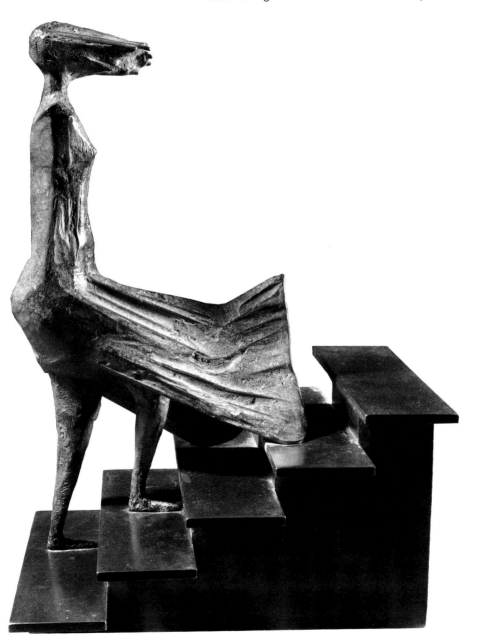

Sculpture in the Open Air

Although Chadwick had certain reservations about showing sculpture in completely natural surroundings, he had quite early on in his career at Lypiatt Park shown some of his work against the stone walls of his house or in a garden setting. He had shown at the early Battersea Park Open-Air Sculpture exhibitions, but had mixed feelings about sculpture parks in general. Nevertheless, it still came as a slight surprise when, in early 1988, he acquired a magnificent stretch of wooded hillside and rough pasture, the Toadsmoor Valley, which adjoined Lypiatt. The farmer had wished to sell this hilly terrain for a flatter plot of land near to his brother's farm, and Chadwick seized the opportunity. After clearing scrub and cleaning out streams, he began placing sculptures in carefully chosen sites in the valley so as to show off their qualities against, say, the skyline or a sward of grass, where the background would remain relatively unchanging, unlike, for example, a screen of trees which would move in the wind or, in winter, present a busy pattern of bare branches. He continued with this work up to the late 1990s and just as the gardens at Lypiatt have matured under his care, so too has the Toadsmoor Valley become alive with his sculpture.

This book is published to coincide with a major display of Chadwick's work in the Duveen Sculpture Galleries of Tate Britain. Apart from an exhibition at the Yorkshire Sculpture Park in 1991–2, this will be the first time his work has been shown on any scale in a British public gallery; yet he achieved international success, has been exhibited worldwide, and is represented in every major museum and gallery in Europe, North and South America, Australia and Japan.

Many years ago, Chadwick broadcast a talk on the BBC Home Service, 'A Sculptor and His Public', in which he expressed his feelings about art, patronage, and art education in our schools. Some of his comments remain valid today, so let him explain for himself:

> To begin with, let me say that a sculptor has no public in the ordinary sense of the word. When I produce something, I hope that someone, some individual will buy it. Public interest or disinterest has no direct impact on me. For the persons who do buy my work are not concerned about how popular it is. Theirs is a personal choice. There are, of course, other people who see my work in public exhibitions, and who form some sort of opinion and can therefore collectively

fig.47
Lypiatt Park seen from
the Toadsmoor Valley

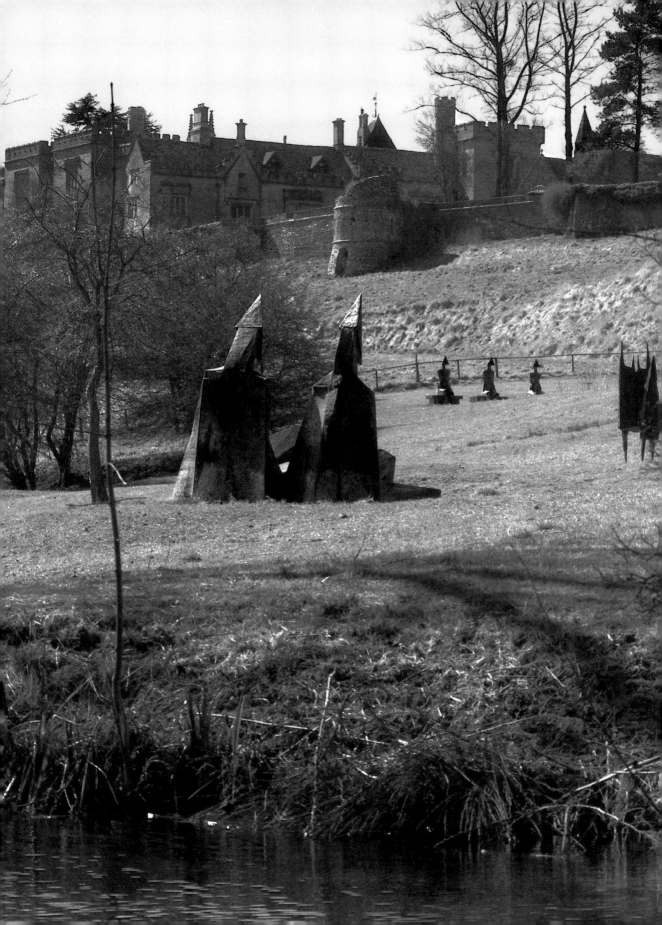

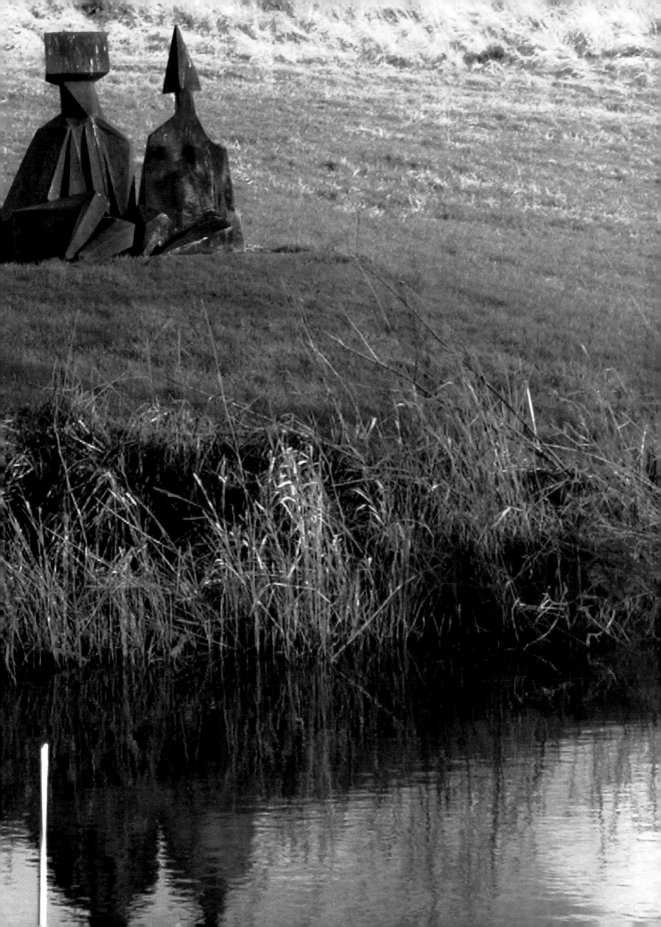

be called a public. But there is no way of gauging their opinion …

It is a great joy to have a visitor who feels for sculpture; who does not fear his own reaction; who knows that appreciation is not in the first place intellectual criticism but enjoyment through the senses; who understands that sculpture, though it may make its literary allusions, has a separate identity, is an expression in form and mass and is vital by reason of what it is …

It seems to me that art must be the manifestation of some vital force coming from the dark, caught by the imagination and translated by the artist's ability and skill into painting, poetry, sometimes music. But whatever the final shape, the force behind it is, as the man said of peace, indivisible. When we philosophise upon this force, we lose sight of it. The intellect alone is still too clumsy to grasp it.[57]

May this exhibition and commentary on Lynn Chadwick's work help to widen and deepen knowledge and enjoyment of his sculpture. He pursued an independent course for much of his career, and is acclaimed worldwide. This is a memorial tribute to one of our greatest contemporary sculptors.

previous pages
fig.48
Two Seated Figures II
1973
Lypiatt Park

fig.49
Crouching Beast IV
1990
Lypiatt Park

fig.50
?Maquette for Winged Female Figure
c.1957
Lypiatt Park

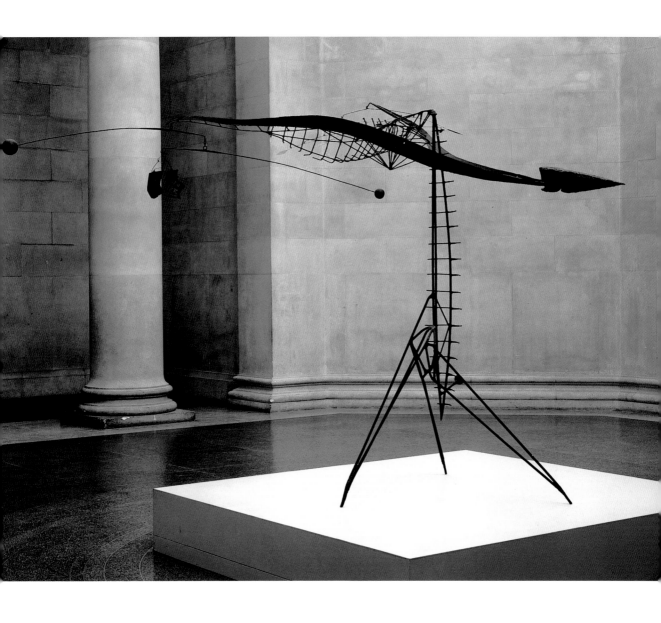

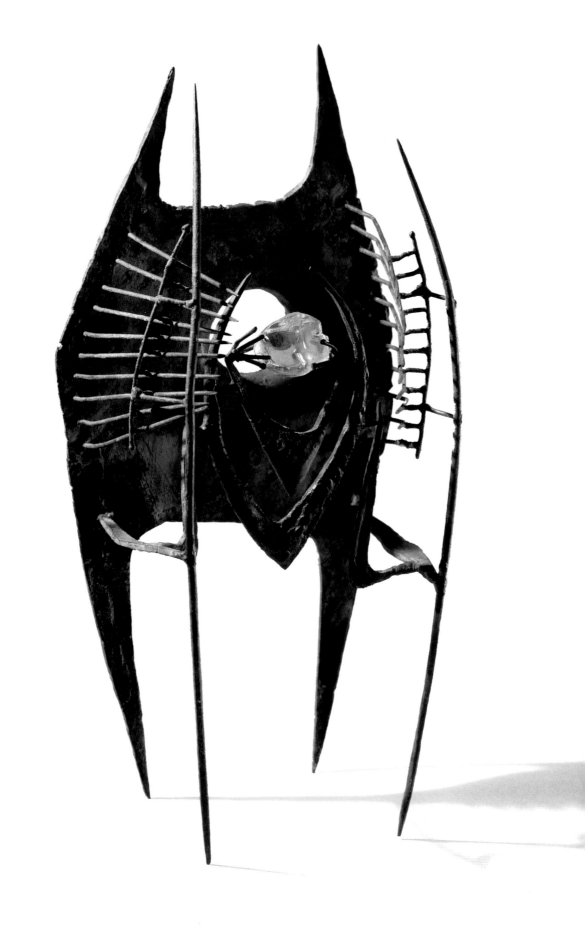

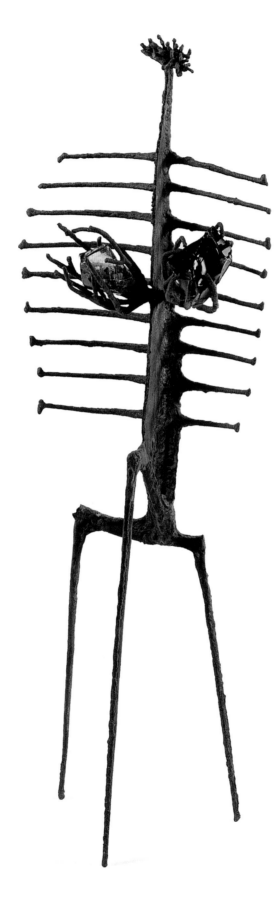

pl.2 (opposite)
Inner Eye (Maquette III)
1952

pl.3
Untitled
1955

Overleaf
pl.4
Dancing Figures
(Two Dancing Figures)
1956

pl.5
Three Elektras
1969

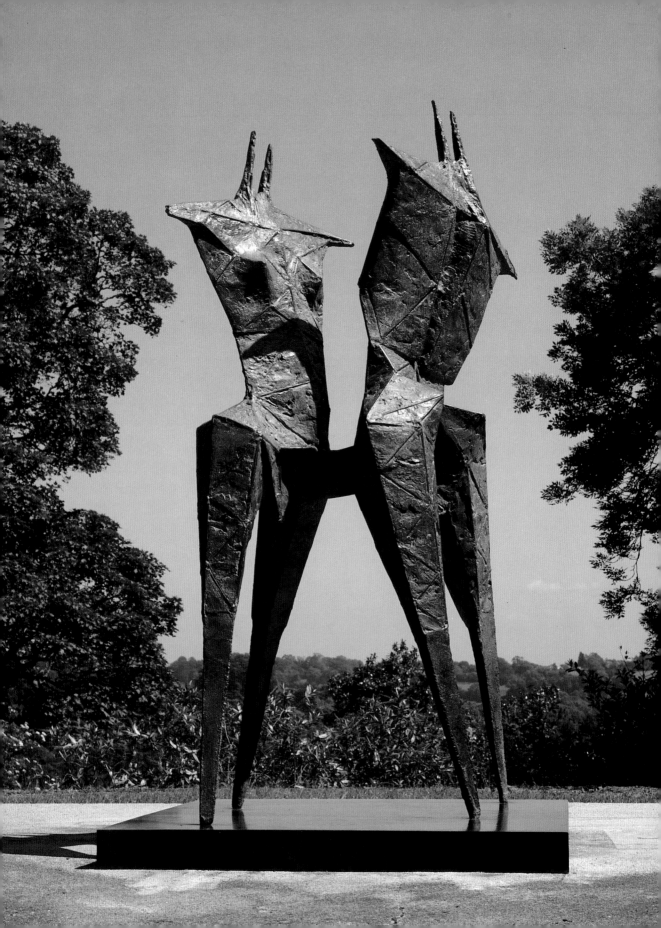

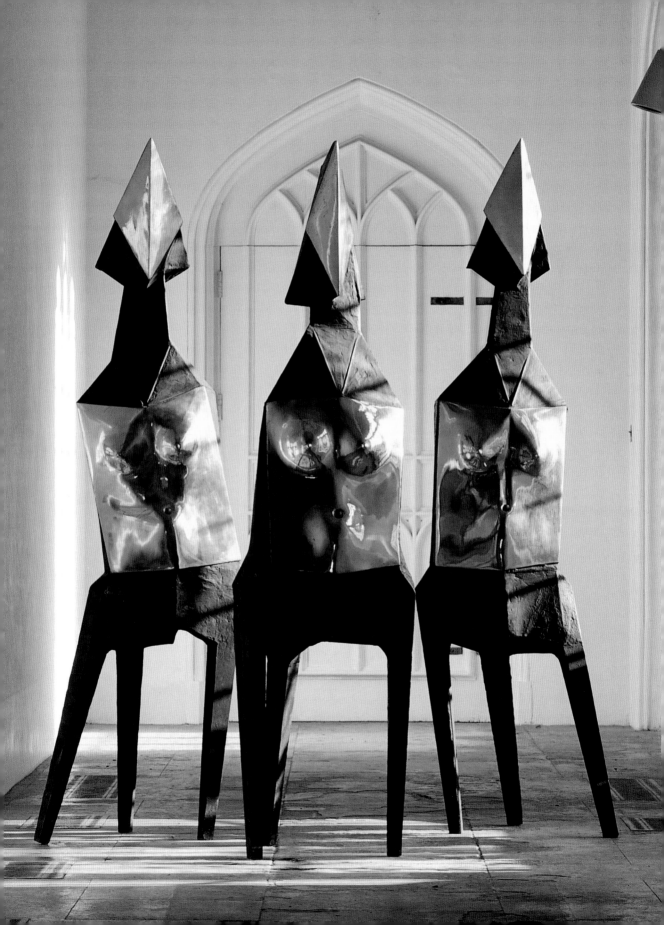

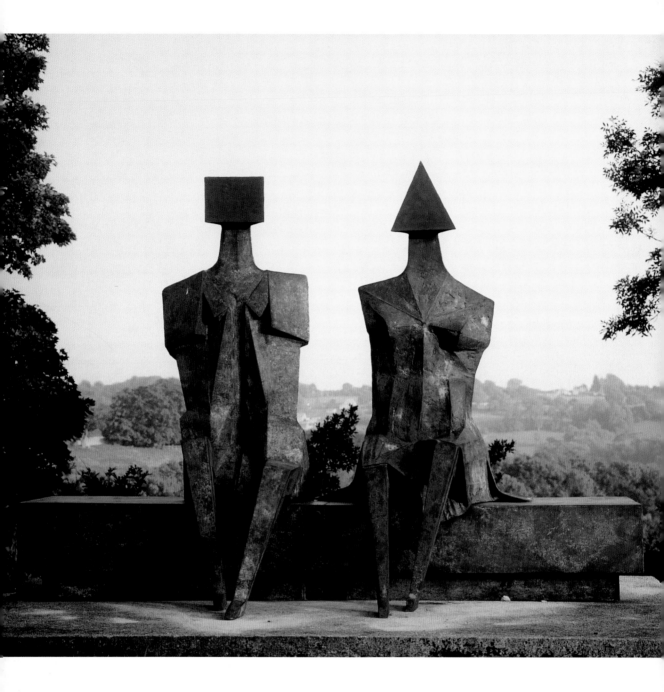

pl.6
Back to Venice
1988

pl.7 (opposite)
Stairs
1991

pl.8 (overleaf)
Beast Alerted I
1990

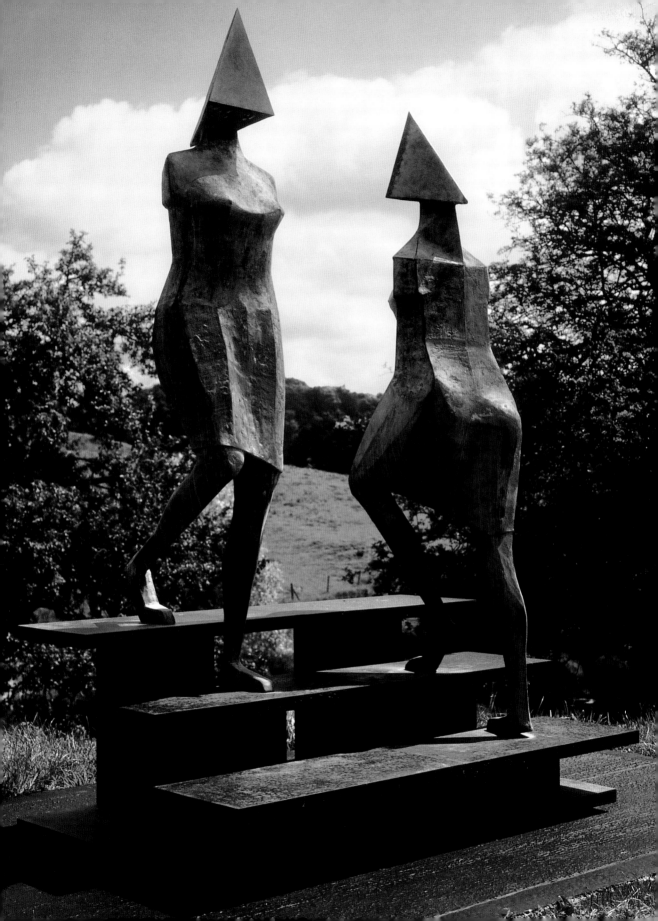

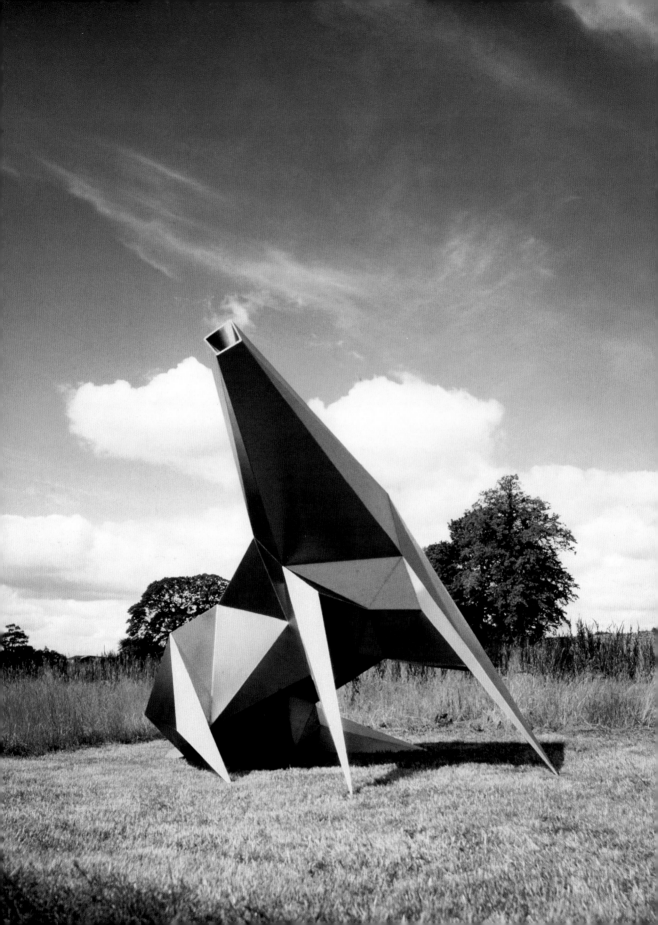

Biography

1914
Lynn Russell Chadwick born 24 November at Ivy Cottage, Station Road, Barnes, the elder child and only son of Verner Russell Chadwick and Margery Brown Lynn.

1926–32
Attended Merchant Taylors' School, London.

1932
Visited France to improve his French: stayed at Vouvray, near Tours (Indre et Loire); returned via Paris; saw Epstein's tomb for Oscar Wilde, Père Lachaise cemetery.

1933–9
Trained and worked as a draughtsman in various architectural firms in London; attended evening classes at Regent Street Polytechnic in attempt to become a qualified architect, but abandoned the course.

c.1936
Mother died; set himself up in flat in Charterhouse Square, London. Visited Germany on a skiing holiday.

1940–1
Worked as a farm labourer in Herefordshire.

1941–4
Volunteered for the Fleet Air Arm, Royal Navy. 1941: elementary training in Detroit; further training in Canada.

Met Charlotte Ann Secord in Toronto and married her in 1942.

First child, Simon, born.

Chadwick qualified as a pilot and commissioned. Based on aircraft carriers, his principal duties were escorting convoys in the North Atlantic. Spring 1944: demobilised.

1944–6
Resumed work with architect Rodney Thomas in London, specialising in exhibition design. Lived in house at 2 Cheyne Row, Chelsea.

1946
March: moved to Fisher's Cottage, near Edge, Stroud, Gloucestershire, on the estate of the architect Detmar Blow.

Won a £50 prize in textile design competition, 'Try Your Hand', promoted by Zika and Lida Ascher.

Made his first mobile, developed from ideas of moving sculptural objects proposed by Rodney Thomas.

1947–52
Produced textile, furniture, and architectural designs.

1947
First mobile shown at the Builders' Trades Exhibition, on the Aluminium Development Association's stand, which he had designed.

c. April: moved to a cottage, Pinswell, near Upper Coberley, four miles south of Cheltenham.

1948
Mobile for Morris Furniture Company of Glasgow stand at British Industries' Fair.

1949
August: small mobile for window of Gimpel Fils, London, as part of a mixed exhibition.

1949–50
December–January: exhibited with the London Group.

1950
March: commissioned by Jane Drew to make a mobile for the Riverside Restaurant Tower, and by Misha Black for a stabile, *Cypress*, to be placed in the garden of the Regatta Restaurant, both for the Festival of Britain South Bank site.

May: wire and perspex mobile for Smith's Clocks, British Industries' Fair, Olympia.

June: first one-man exhibition, Gimpel Fils, London.

Summer: took welding course at British Oxygen Company's Welding School, Cricklewood.

1951
Festival of Britain South Bank exhibition: metal and wood mobile for the Tower, Riverside Restaurant and stabile *Cypress* for the Regatta Restaurant Garden.

May–September: exhibited *Green Finger (Mobile)* at the second Open-Air Sculpture Exhibition, Battersea Park Festival Garden. Visited Toronto and New York.

July: *Fisheater* mobile commissioned by the Arts Council shown at the RBA Galleries.

November: two mobiles for Hertford Schools, Hertford.

1952
Second one-man exhibition at Gimpel Fils, also shown at the Galerie de France, Paris. Included in British Council's *New Aspects of British Sculpture* exhibition for the XXVI Biennale, Venice. Member of the London Group.

1953
First solid sculptures produced.

March: one of twelve semi-finalists for *The Unknown Political Prisoner* International Sculpture Competition organised by the Institute of Contemporary Arts, London – awarded honourable mention and £250 prize.

1955
Visited Greece: Mykonos and Delos.

1956

Won the International Prize for Sculpture, XXVIII Biennale, Venice.

Visited Venice, Amsterdam, and Brussels.

First lithograph published by Bodensee-Verlag, Amriswil, Switzerland.

Elected member of Wiener Secession, Vienna.

1957–8

Commissioned by Air League of the British Empire, on recommendation of the R34 Memorial Committee, to produce memorial to commemorate successful double crossing of the Atlantic by the airship R34 in July 1919. Model accepted July 1957; full-scale sculpture *Stranger III* accepted for London Airport site July 1958, but Air League bowed to furious opposition and withdrew proposal, December 1958.

1958

January: visited Munich and Zurich.

September: moved to Lypiatt Park near Stroud, Gloucestershire.

1959

Won first prize, III Concorso Internazionale del Bronzetto, Padua.

Divorced from first wife (she died in 1997).

Married Frances Mary Jamieson: daughters Sarah and Sophie.

1960

Signed two-year contract with Marlborough Fine Art, London; regularly exhibited with them.

1961

Exhibited *hors concours* at VI Bienal de São Paulo, Brazil.

1962

Prizewinner at VII Esposizione di Bianco e Nero, Lugano.

Artist in Residence for a term at Ontario College of Art, Toronto.

Invited by Italsider S.p.A., Genoa, with Alexander Calder and David Smith, to carry out an open-air sculpture project for the Festival dei Due Monde at Spoleto, on recommendation of Giovanni Carandente, Museo d'Arte Moderna, Rome.

June: *Two Winged Figures*, monumental steel box structures, exhibited at Spoleto.

1963

Received Carborundum Company's Sculpture Major and Minor Awards to produce circular sculpture in fibreglass, *Manchester Sun*, for the front of the Williamson Building for Life Sciences, University of Manchester.

1964

Appointed Commander, Order of the British Empire (CBE) in the New Year Honours.

Death of Frances Chadwick.

Represented in London Group 1914–64 Jubilee Exhibition (although ceased to be a member in 1963).

Elected member of the Accademia di San Luca, Rome.

Elected member of the Accademia Fiorentina delle Arti e Disegno, Florence.

Married Eva Yvonne Reiner: one son, Daniel Sebastian.

1968
Environmental sculpture for Milan Esposizione Triennale.

1970
Made jewellery with Rebecca John.

1971
Opened his own foundry at Lypiatt Park.

1973
Four lithographs for Club S. Erasmo, Milan.

1984
Commissioned by the British Art Medal Society to design a medal, *Diamond*, struck by the Pobjoy Mint for the BAMS.

1985
June: created Officier, Ordre des Arts et des Lettres, France.

1986
Autumn: acquired large L-shaped warehouse in Chalford, near Lypiatt, and equipped it as a workshop and sculpture store.

1988
February: chairman of jury, sculpture project for new Glaxo Building, Verona.

Visited Miami and Caracas, Venezuela, in connection with a touring exhibition.

June-September: invited by the Director of the XLIII Venice Biennale to contribute bronze, *Back to Venice*, in special international sculpture survey.

November: appointed to the Order of Andres Bello – First Class, Venezuela.

1989
March: acquired second workshop and drawing studio at Chalford.

24 April: inauguration of *Hello Paris* at Le Ponant de Paris.

Summer: began to place sculpture in Toadsmoor Valley, adjoining Lypiatt Park.

Closed foundry, appointed Rungwe Kingdon of Pangolin Editions to cast all his work.

1993
Created Commandeur, Ordre des Arts et des Lettres, France.

1995
Created Associate, Académie Royale de Belgique, Belgium and Honorary Fellow, Cheltenham and Gloucester College of Higher Education.

1996
Failing eyesight forced him to retire; he became increasingly infirm.

1998
Created Honorary Fellow, Bath Spa University College, Bath.

2001
Elected a Senior Royal Academician, Royal Academy of Arts, London.

2003
25 April: died in his sleep at Lypiatt Park. He was buried there in the Pinetum.

Notes

1
Butler qualified as an architect (ARIBA) in 1937.

2
Artist's statement in *The New Decade: 22 European Painters and Sculptors*, Museum of Modern Art, New York 1955, pp.70–1.

3
Ibid., p.70.

4
Ibid., p.70.

5
Ibid., p.71.

6
For a detailed biographical account see Farr and Chadwick 1990 (and reprinted eds. 1997 and 2001). See Select Bibliography.

7
Farr and Chadwick 1990, p.2. Recorded conversations with the author (10–11 April 1987), referred to henceforth as LC/DF April 1987. Quotations from Chadwick, unless otherwise noted, are taken from these recorded conversations.

8
Chadwick's mother died in 1936: *Artists' Lives: Lynn Chadwick (April-May 1995)* interviewed by Cathy Courtney, British Library Sound Archive, National Life Story Collection ref. C466/023/F 4557-A, p.96 (henceforth referred to as BL Artists' Lives 1995, with tape number). When quoting I have occasionally done some minor editing of the tapes to avoid repetition and to ensure clarity of meaning. Chadwick had moved out from his home by this time (1936) and had a small flat in Charterhouse Square.

9
BL Artists' Lives 1995, F 4556-A, p.57. Chadwick made no specific comment in 1995 on his early experiences of seeing these works, but he enjoyed these Sunday morning forays with his parents, which usually ended with lunch in Soho.

10
Trevor Dannatt, *Modern Architecture in Britain* 1959, p.15 of John Summerson's introduction.

11
In his first *Who's Who* entry of 1957 and subsequently, he described himself as 'sculptor since 1948'.

12
The competition was promoted by the textile firm run by Zika and Lida Ascher. For further details see Farr and Chadwick 1990, p.3 and n.14.

13
See Farr and Chadwick 1990, p.17, n.19, for details of a discussion Farr had with Rodney Thomas and Chadwick about this point in November 1987. When Chadwick first saw Calder's work in the mid-1950s he rejected it, because it 'had a different viewpoint, a different aesthetic'. He later came to admire it.

14
The Gimpel Fils catalogue lists fourteen works, all but four of which were described as 'mobile supported on own stand'.

15
Chadwick was paid £300 for the stabile, including materials, according to his Workbooks.

16
BL Artists' Lives 1995, F 4559-B, p.163.

17
D. Farr, *British Sculpture since 1945*, Tate Gallery 1965, n.p. [5].

18
LC/DF April 1987.

19
BL Artists' Lives 1995, F 4559-A, pp.155–6.

20
Andrew Causey, *Lynn Chadwick: Sculpture 1951–1991*, Yorkshire Sculpture Park 1991, p.13.

21
BL Artists' Lives 1995, F 4563-B, p.288.

22
Ibid., F 4559-A, p.156.

23
The Seasons, CAS, Tate Gallery, March–April 1956, no.48.

24
The other sculptors were: Robert Adams, Kenneth Armitage, Reg Butler, Geoffrey Clarke, Bernard Meadows, Eduardo Paolozzi and William Turnbull.

25
Herbert Read, 'New Aspects of British Sculpture', *Exhibition of Works by Sutherland, Wadsworth, Adams, Armitage, Butler, Chadwick …Turnbull*, organised by the British Council for the XXVI Biennale, Venice 1952, n.p., for this and subsequent quotations.

26
Herbert Read, *Lynn Chadwick*, Bodensee Verlag, Amriswil, Switzerland, 1958 and 1960 edn., pp.8–9.

27
L. Chadwick, 'A Sculptor and His Public', *The Listener* (21 October 1954), p.671.

28
Farr and Chadwick 1990, p.10 and nn.39–42; E. Lucie-Smith, *Chadwick* (1990), p.26. Both give accounts of the award and of its reception by the critics. LC told Lucie-Smith that in 1956 Italian artists became eligible for the first time to compete for the main sculpture prize, but that Manzù dropped out when it was thought Giacometti might win.

29
D. Sutton, *Financial Times*, 19 June 1956, and 'The Problems of the Biennale', *Quadrum* 2, November 1956, pp.89–95. There were also tensions within the British Council between the Executive and the Fine Art Department, whose judgment in selecting Chadwick and other young contemporary artists was questioned by Sir Paul Sinker and Sir David Kelly (Director General of the British Council and Chairman of the Executive respectively); see Margaret Garlake, 'Pavilion'd in Splendour', *Art Monthly*, no.117, June 1988, pp.7–8.

30
A. Bowness, 'The Venice Biennale', *Observer*, 24 June 1956. Quoted in Koster and Levine 1988, p.77 (see Select Bibliography).

31
Confirmed in conversation with the author, 9 March 2002; E. Lucie-Smith 1997, p.32 also makes this connection.

32
BL Artists' Lives 1995, F 4564-B, p.336.

33
Ibid., p.333.

34
LC/DF April 1987.

35
See R. Alley, *The Tate Gallery's Collection of Modern Art, other than works by British Artists*, 1981, pp.99–100, s.v. T.183. I am grateful to Dr Sarah Wilson for reminding me of this work.

36
E. Lucie-Smith 1997, p.71.

37
Letter from H.M. Fairhurst to Francis W. Hawcroft, dated 5 June 1987, in the author's possession. Hawcroft, then at the University of Manchester's Whitworth Art Gallery, had written to Fairhurst on my behalf. I believe Chadwick's memory may have misled him in recalling the actual circumstances.

38
BL Artists' Lives 1995, F 4564-B, p.338.

39
Ibid., p.338.

40
D. Farr, *English Art 1870–1940*, Oxford 1978, pp.251–2 and n.1 (Henry Moore in conversation with the author, December 1971).

41
BL Artists' Lives 1995, F 4564-A, p.306.

42
Ibid., p.308.

43
Ibid., F 4563-B, p.298.

44
Ibid., F 4564-A, p.311.

45
LC had made jewellery with Rebecca John, Admiral Caspar John's daughter, in 1970. He had known the John family from his post-war Chelsea days.

46
LC/DF April 1987 and BL Artists' Lives 1995, F 4562-B, pp.259–60.

47
The title refers to HM the Queen's Silver Jubilee of 1977.

48
BL Artists' Lives 1995, F 4564-A, p.319.

49
LC/DF April 1987.

50
LC letter to DF dated 15 August 1988.

51
See Farr and Chadwick 1990 and 1997, p.3 and n.12, for more information about this aspect of his career.

52
BL Artists' Lives 1995, F 4565-A, pp.346–7.

53
Ibid., F 4564-A, p.322.

54
Ibid., pp.322–3.

55
Ibid., F 4565-A, pp.340–1.

56
LC/DF April 1987 and BL Artists' Lives 1995, F 4564-B, p.330.

57
LC, 'A Sculptor and His Public', *Listener*, 21 October 1954, p.671; also quoted in part above (p.41).

Select Bibliography

Place of publication is London, unless otherwise stated.

1954
Chadwick, Lynn, 'A Sculptor and His Public', talk broadcast on the BBC Home Service, published in the *Listener,* 21 October 1954, pp.671–5

1955
Chadwick, Lynn, Artist's Statement in *The New Decade: 22 European Painters and Sculptors*, exh. cat., Museum of Modern Art, New York 1955, pp.70–1

1958
Read, Herbert, *Lynn Chadwick*, Artists of Our Time/Künstler Unserer Zeit, iv, Bodensee-Verlag, Amriswil, Switzerland, 1958, 2nd ed. 1960. Text in English and German

1961
Hodin, Josef Paul, *Chadwick*, Modern Sculptors, Zwemmer 1961

1962
Bowness, Alan, *Lynn Chadwick*, Art in Progress, Methuen 1962

1988
Koster, Nico and Levine, Paul, *Lynn Chadwick: The Sculptor and His World*, photographed by Nico Koster; *The Artist and His Work*, text by Paul Levine; Chronology and lists compiled by Eva Chadwick, SMD Informatief Spruyt, Van Mantgen & De Does, Leiden, 1988

1990
Farr, Dennis and Chadwick, Eva, *Lynn Chadwick. Sculptor. With a Complete Illustrated Catalogue 1947–88*, Clarendon Press, Oxford, 1990; reprinted with corrections 1992; catalogue expanded to 1996, Lypiatt Studio, Stroud, Gloucestershire, 1997; reprinted 2001

1991
Farr, Dennis, *Lynn Chadwick*, exh. cat., Museum of Modern Art, Toyama; Museum of Modern Art, Saitama; Hakone Open-Air Museum; Museum of Kyoto, 1991. Text in English and Japanese

1991
Causey, Andrew, *Lynn Chadwick. Sculpture 1951–1991*, exh. cat., Yorkshire Sculpture Park, Bretton Hall, Wakefield, West Yorkshire, 1991

1997
Lucie-Smith, Edward, *Chadwick*, Lypiatt Studio, Stroud, Gloucestershire, 1997

List of Exhibited Works
(15 September 2003 – 21 March 2004)

Numbers in parentheses after the title
refer to the Farr and Chadwick catalogue
(1990; see Select Bibliography)

Measurements are given in centimetres,
followed by inches in brackets.
Abbreviations: ht = height; w. = width;
d. = depth; l. = length; diam. = diameter

Stabile with Mobile Elements
1950 (41)
Brass wire, copper and brass triangles,
ht 127 (50)
Unique
Lypiatt Studio
[fig.1]

Stabile with Mobile Elements
(Maquette for 'Cypress')
1950 (44)
Wire, slate and brass, ht 76 (26)
Unique
Lypiatt Studio
[fig.3]

Dragonfly
1951 (55)
Welded iron and steel, diam. c.295 (116)
Unique
Tate
[fig.4]

Fisheater
1951 (51)
Iron and copper, ht 228 (90)
Unique
Tate
[fig.5, pl.1]

Inner Eye (Maquette III)
1952 (75)
Iron and glass, ht 28 (11)
Unique
Tate
[pl.2]

Maquette for Unknown Political Prisoner
1953 (96)
Welded iron, ht 43 (17)
Unique
Lypiatt Studio
[fig.8]

Idiomorphic Beast
1953 (100)
Welded iron, ht 81 (32)
Unique
Bristol Museums and Art Gallery
[fig.9]

Conjunction
1953 (120)
Iron and composition, ht 40 (16)
Unique
Tate
[fig.10]

Maquette for The Stranger
1954 (144)
Iron and silver, ht 52 (20 ¾)
Unique
Lypiatt Studio
[fig.13]

The Seasons
1955 (157)
Iron and composition, ht 53 (21)
Unique
Arts Council Collection,
Hayward Gallery, London
[fig.11]

Untitled
1955 (164)
Iron and glass, ht 86 (34)
Unique
Lypiatt Studio
[pl.3]

Teddy Boy and Girl
1955 (170)
Bronze, ht 190 (75)
Edition: 6
Lypiatt Studio
[fig.17]

Dancing Figures (Two Dancing Figures)
1956 (175)
Iron and composition, ht 184 (72 ½)
Unique
Lypiatt Studio
[pl.4]

Beast VII
1956 (198)
Iron and composition, l. 112 (44)
Working model for bronze
Unique
Lypiatt Studio
[fig.16]

Stranger II
1956 (210)
Bronze, ht 210 (43 ½)
Edition: 4
Lypiatt Studio
[fig.21]

Moon of Alabama
1957 (246)
Bronze, ht 152 (60)
Edition: 6
Lypiatt Studio
[fig.18]

Maquette for R34 Memorial
1956 (251)
Bronze, ht 35 (13 ¾)
Edition: 9
Lypiatt Studio
[fig.19]

Stranger III
1959 (285)
Bronze, ht 218 (86), w. 264 (104)
Edition: 4
Lypiatt Studio/Sculpture at Goodwood
[fig.20]

The Watchers
1960 (325)
Bronze, ht 235 (92 ½)
Edition: 3
Lypiatt Studio
[fig.23]

Three Elektras
1969 (569)
Bronze (polished face and torso),
ht 226 (89 ¼), 223 (88), 219 (86 ½)
Edition: 4
Lypiatt Studio
[pl.5]

Diamond
1970 (596)
Bronze, ht 75 (29 ½)
Edition: 6
Lypiatt Studio
[fig.29]

Sitting Figure
1970 (608)
Bronze, l. 45 (18)
Edition: 6
Lypiatt Studio
[fig.30]

Five Sitting Figures
1975 (617S)
Bronze, ht 17 (6 ¾)
Edition: 8
Lypiatt Studio
[fig.32]

Two Reclining Figures
1972 (642)
Bronze, l. 183 (72)
Edition: 4
Lypiatt Studio
[fig.33]

Cloaked Figure IX
1978 (770)
Bronze, ht 185 (73), w. 101 (40), d. 140 (55)
Edition: 6
Lypiatt Studio
[fig.34]

Maquette Jubilee II
1983 (C3)
Bronze, male ht 89 (35), female ht 91 (36)
Edition: 9
Lypiatt Studio
[fig.35]

Maquette V High Wind
1984 (C21)
Bronze, ht 29 (11 ½)
Edition: 9
Lypiatt Studio
[fig.36]

Maquette VIII High Wind
1986 (C32)
Bronze, ht 18 (7)
Edition: 9
Lypiatt Studio
[fig.37]

Back to Venice
1988 (C74)
Bronze, ht 193 (76), w. 276 (109), d. 152 (60)
Edition: 9
Lypiatt Studio
[pl.6]

High Wind II
1988 (C77)
Bronze, ht 188 (74), w. 94 (37), d. 95 (38 ½)
Edition: 9
Lypiatt Studio
[fig.41]

Crouching Beast I
1990 (C108)
Welded stainless steel,
ht 122 (48), w. 142 (56), l. 315 (124)
Edition: 6
Lypiatt Studio
[fig.44]

Beast Alerted I
1990 (C110)
Welded stainless steel,
ht 228.5 (90), w. 183 (72), l. 324.5 (128)
Edition: 6
Lypiatt Studio
[pl.8]

Stairs
1991 (C126)
Bronze, ht 239 (94), w. 160 (63), d. 112 (44)
Edition: 9
Lypiatt Studio
[pl.7]

High Wind on Stairs III
1994 (C134)
Bronze, ht 34 (13 ½), w. 23 (9), d. 26 (10 ½)
Edition: 9
Lypiatt Studio
[fig.46]

List of Additional Illustrations

fig.2
Stabile (Cypress)
1951
Copper sheet and brass rods, ht 396 (156)
Destroyed

fig.6
The Inner Eye
1952
Iron and glass, ht 228 (90)
The Museum of Modern Art, New York

fig.7
Bullfrog
1951
Bronze, ht 66 (26)

fig.12
Bird
1956
Iron and composition, l. 70 (27 ½)
Lypiatt Studio

fig.14
**Installation photograph
of Venice Biennale**
1956
Lypiatt Studio

fig.15
**Installation photograph
of Venice Biennale**
1956, showing *Idiomorphic Beast* 1953,
The Seasons 1955, and *The Inner Eye* 1952
Lypiatt Studio

fig.22
Manchester Sun
1963–4
Fibreglass with gold leaf, diam. 487 (192)
Manchester University, Williamson Building,
Manchester

fig.24
Tower of Babel VII
1964
Bronze, ht 65 (25 ½)

fig.25
Two Winged Figures
1962
Welded iron, ht 296 (116 ½), w. 559 (220)
Lypiatt Studio

fig.26
Proctor
1964
Bronze, ht 78 (31)

fig.27
Eduardo Paolozzi, **Cyclops**
1957
Bronze, ht. 111.1 (43 ¾), w. 30.5 (12), d. 20.3 (8)
Tate

fig.28
Conjunction X
1964
Bronze, ht 71 (28)

fig.31
Hello Paris
1988
Stainless steel,
ht 380 (149 ½), w. 95 (37 ½), d. 95 (37 ½)
Le Ponant de Paris

fig.38
Amenhotep III
1400 BC
Black granite, ht 235 (92 ½)
The British Museum, London

fig.39
Henry Moore, **King and Queen**
1952–3
Bronze, ht. 163.8 (64 ½), w. 138.4 (54 ½), d. 84.5
(33 ¼)
Tate

fig.40
Pharaoh's Dream
1989
Bronze, ht 18 (7)
Lypiatt Studio

fig.42
Palm Beach Blue
1988
Stainless steel and blue paint,
ht 348 (137), w. 90 (35 ½), d. 70 (27 ½)
Palm Beach Airport, Florida

fig.43
Inox
1989
Welded stainless steel,
ht 19.9 (78 ½), w. 66 (26), d. 56 (22)

fig.45
Spiral II
1991
Bronze, ht 67 (26 ½), w. 51 (20), d. 51 (20)

fig.47
Lypiatt Park seen from Toadsmoor Valley
Lypiatt Studio

fig.48
Two Seated Figures II
1973
Bronze, male ht. 165 (65), female ht. 173 (68)
Lypiatt Park

fig.49
Crouching Beast IV
1990
Welded stainless steel, ht 61 (24), w. 71 (28),
l. 157.5 (62)
Lypiatt Park

fig.50
?Maquette for Winged Female Figure
*c.*1957
Lypiatt Park

Lenders and Credits

Lenders

Arts Council Collection, Hayward Gallery, London fig.11

Bristol Museums and Art Gallery fig.9

Lypiatt Studio figs.1, 3, 6, 8, 13, 16, 17, 18, 19, 21, 23, 29, 30, 32, 33, 34, 35, 36, 37, 40, 41, 44, 46; pls.3, 4, 5, 6, 7, 8

Lypiatt Studio/Sculpture at Goodwood (www.sculpture.org.uk) fig.20

Tate figs.4, 5, 10; pls.1, 2

Photo Credits

The British Museum fig.38

Bristol Museums & Art Gallery fig.9

Mike Fear 2003 fig.11

Courtesy of Lypiatt Studio figs.1, 2, 3, 5, 8, 12, 13, 14, 15, 16, 17, 18, 19, 20, 21, 22, 23, 24, 25, 26, 27, 28, 29, 30, 31, 32, 33, 34, 35, 36, 37, 40, 41, 42, 43, 44, 45, 46, 47, 48, 49, 50; pls.3, 4, 5, 6, 7, 8

© 2003 The Museum of Modern Art, New York fig.6

Pembroke College, Oxford, JCR fig.7

Tate Photography fig.10

Tate Picture Library figs.4, 27, 39; pls.1, 2

Copyright Credits

Works by Lynn Chadwick © Lypiatt Studio 2003

Henry Moore reproduced by permission of the Henry Moore Foundation

Eduardo Paolozzi © Eduardo Paolozzi 2003 All rights reserved, DACS

Index

a
Adams, Robert 41
African carvings 61
aluminium 58
architectural draughtsman, training as 8,
 12–13, 87, 113
Armitage, Kenneth 41
Arp, Jean 15
Ascher, Zika and Lida 15, 113

b
Back to Venice 83–4, 116; pl.6
Bacon, Francis
 *Triptych inspired by the 'Oresteia' of
 Aeschylus* 68
Barley Fork 28
Beast series 88, 93; fig.44; pl.8
Beast Alerted I 88, 93; pl.8
Beast VII 51–2; fig.16
Beast XVIII 93
Bird 35; fig.12
Black, Misha 19, 22, 114
Blake, William 40
Blow, Detmar 113
Bowness, Alan 44
Brabazon of Tara, Lord 58
bronze 8, 44, 73, 83–4
Brown, K.F.P. 12
Bullfrog 28; fig.7
Butler, Reg 8, 16, 28

c
Calder, Alexander 17, 62, 65, 115
Carandente, Giovanni 115
Caro, Anthony 65
CBE, Chadwick appointed 69, 115
César 16
 L'Homme de Saint-Denis 55, 58
Chadwick, Daniel Sebastian (son) 72, 115
Chadwick, Eva *see* Reiner, Eva Yvonne
Chadwick, Sarah (daughter) 72, 115
Chadwick, Simon (son) 13, 113
Chadwick, Sophie (daughter) 72, 115
Clarke, Geoffrey 41

Clatworthy, Robert 41
Cloaked Figure IX 76; fig.34
Coleridge, Samuel Taylor 40
colour 19, 25, 62, 65, 68, 87
Conjunction 35; fig.10
Conjunction X 65; fig.28
Constable, John 13
Crouching Beast I 88; fig.44
Crouching Beast IV fig.49
Cubism 15–16

d
Dancing Figures (Two Dancing Figures) 51, 69;
 pl.4
Degas, Edgar 79
Delos, avenue of lions 52
Diamond 69, 87; fig.29
Diamond (medal) 116
Diamond Trigon II 87
Dragonfly 22, 25, 93; fig.4
drawings 44, 51
Drew, Jane 19, 114

e
Easter Island figures 52, 61–2
Egyptian sculpture 83; fig.38
Elektra series 62, 68, 73; pl.5
Epstein, Jacob 13, 15, 52, 113
exhibitions
 1938 MARS Group *New Architecture* 13
 1950 Gimpel Fils 19, 114
 1952 Venice Biennale 12, 40–1, 114
 1956 Venice Biennale 41, 44, 115
 1962 Festival dei Due Monde, Spoleto 62,
 65, 115
 1968 Milan Exposizione Triennale 65, 116
 1988 Venice Biennale 83, 116
 1991–2 Yorkshire Sculpture Park 96

f
Fairhurst, Harry M. 61
Festival of Britain 19, 22, 114
fibreglass 58, 61

figurative works 8
Fisheater 22, 25, 114; fig.5; pl.1
Five Sitting Figures 69; fig.32
Fry, Maxwell 19
furniture designs 16

g
gardening 53
'geometry of fear' 40–1
Giacometti, Alberto 41, 44
Gibberd, Frederick 55
Gimpel Fils 19, 114
glass 24, 28, 38
gold leaf 58, 61
Gonzalez, Julio 16
Green Finger (Mobile) 114
Gropius, Walter 15, 19

h
Hamilton, Donald 12
Hello Paris 69, 87, 116; fig.31
Hepworth, Barbara 15, 35, 40
High Wind series 79, 84, 93–4;
 figs.36, 37, 41, 46
High Wind II 84; fig.41
High Wind on Stairs III 93–4; fig.46

i
Idiomorphic Beast 28, 35, 44; fig.9
Impressionism 13
The Inner Eye 25, 28, 38, 44; fig.6
Inner Eye (Maquette III) 25; pl.2
Inox 87; fig.43
International Sculpture Prize 44, 115
iron 8–9, 16, 22, 28, 35, 38
Italsider Steelworks, Genoa 62, 65, 88, 115

j
Jamieson, Frances Mary (second wife) 72, 115
jewellery 116
John, Rebecca 116
Jung, C.G. 40

k
Kandinsky, Wasilly 93
Kaufmann, Eugen C. 12
Kingdon, Rungwe 73, 116

l
Le Corbusier 13, 15, 52
lithographs 115, 116
London Group 114, 115
Lubetkin, Bertholdt 15
Lypiatt Park 53, 73, 96; figs.47–50
 foundry 73, 116

m
Magritte, René 84
Manchester Sun 58, 61, 115; fig.22
Maquette for Apollo 58
Maquette V High Wind 79; fig.36
Maquette VIII High Wind 79; fig.37
Maquette Jubilee II 79; fig.35
Maquette for R34 Memorial 55, 58, 115; fig.19
Maquette for The Stranger 38, 52, 55; fig.13
Maquette for Unknown Political Prisoner 28,
 52, 65, 114; fig.8
Maquette for Winged Female Figure [?] fig.50
Marini, Marino 76
Marlborough Fine Art 69, 115
Matisse, Henri 15, 61
Meadows, Bernard 41
Minton, John 40
mobiles 8, 16–17, 19, 22, 61, 113, 114
Moon of Alabama 52; fig.18
Moore, Henry 15, 35, 40, 52, 94
 helmet heads 28
 King and Queen 83–4; fig.39
 Two-Piece Reclining Figure series 69
movement 8, 79

n
natural forms 8, 15, 22, 25, 35
neo-Romanticism 40

o
Ontario College of Art residency 95, 115
Oscar 65

p
Pair of Walking Figures – Jubilee 79
Palm Beach Blue 69, 87; fig.42
Paolozzi, Eduardo 41, 65
 Cyclops 65; fig.27
Pasmore, Victor 58
Pharaoh's Dream 84; fig.40
Picasso, Pablo 15, 16, 61
polishing 68
Pop art 65
Post-Impressionism 13
Proctor 65; fig.26

r
R34 Memorial 55, 58, 115; fig.19
Rad Lad 65, 87
Read, Herbert 40–1
ready-made objects, use by Chadwick 65
Reiner, Eva Yvonne (third wife) 72, 115
Rodin, Auguste 15

s
Sabin, Sidney F. 55
'A Sculptor and His Public' 96, 104
The Seasons 38, 40, 44; fig.11
Second World War 13, 40, 113
Secord, Charlotte Ann (first wife) 13,
 72, 113, 115
Shakespeare, William 40
silver 38
siting sculpture, Chadwick's views 58, 61, 96
Sitting Figure 69; fig.30
Skylon 22
Slate shape and iron rods 19
Smith, David 62, 65, 87–8, 115
Spence, Basil 17
Spiral II 94; fig.45
Stabile (Cypress) 19, 22, 114; fig.2
Stabile with Mobile Elements 19; fig.1
*Stabile with Mobile Elements (Maquette for
 'Cypress')* 19, 114; fig.3
stainless steel 62, 65, 69, 87–8, 93, 115
Stairs series 84, 93–4; figs.45, 46; pl.7
Stairs 94; pl.7

t
Stolit 28, 35, 83, 94
'Stranger' theme 38; fig.13
Stranger II 55; fig.21
Stranger III 55, 58, 61, 115; fig.20
Summerson, John 13
Surrealism 40, 84
Sutherland, Graham 25
Sutton, Denys 44
Sylvester, David 44

t
Teddy Boy and Girl 44, 51, 76, 93; fig.17
textile designs 15, 16, 113, 114
Thomas, Rodney 12, 13, 16–17, 19, 87, 113
Three Elektras 62, 68, 83; pl.5
Toadsmoor Valley 96, 116 fig.47
Tower of Babel 65; fig.24
Turnbull, William 41
Turner, J.M.W. 13
Two Reclining Figures 73, 76; fig.33
Two Seated Figures II fig.48
Two Winged Figures 62, 65, 87, 115; fig.25

u
Unknown Political Prisoner International
 Sculpture Competition (1952) 28, 52, 65,
 114; fig.8
Untitled (1955) 38; pl.3

w
Walking Figures series 79; figs.35–7
Wall, Brian 65
The Watchers 41, 61–2, 65, 68, 73, 76, 87, 93;
 fig.23
watercolour 13
Watkinson, Harold 55
Watts, G.F. 13
welding 8–9, 16, 19, 22, 94
Winged Figures series 62, 65, 76; fig.25
Workbooks 51